EUROPEAN
FOLK ART DESIGNS

EUROPEAN FOLK ART DESIGNS

Marty Noble

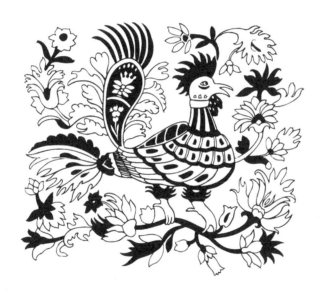

DOVER PUBLICATIONS, INC.
Mineola, New York

Bibliographical Note

European Folk Art Designs is a new work, first published by Dover Publications, Inc., in 2004.

DOVER *Pictorial Archive* SERIES

International Standard Book Number

ISBN-13: 978-0-486-43757-6
ISBN-10: 0-486-43757-4

Manufactured in the United States by Courier Corporation
43757402
www.doverpublications.com

Introduction

In this diverse and carefully chosen collection, you'll find a treasury of designs drawn from the centuries-old folk art traditions of many European lands. Taken from a host of original sources—textiles, earthenware, furniture, embroidery, clothing, shoes, cupboards, wine bottles, boxes, plates, and many other items in common use—these motifs derive directly from the life of the people and the popular culture of Austria, Denmark, France, Germany, Greece, Hungary, Italy, Norway, Poland, Spain, Sweden, and many more countries.

Included here are sixty plates (two to nine designs per plate) of plant and animal motifs, Christmas and holiday decorations, abstracts, geometric motifs, religious figures (Madonnas, saints, etc.), and other designs originally employed to add decorative flair to interiors, household objects, utilitarian items, and personal possessions. Sometimes highly stylized, often full of charm and whimsy, these images have been handed down for generations, offering a rich connection with artists and craftspeople of times past.

Ranging from simple to intricate, delicate to bold, realistic to highly imaginative, the designs in this book will help you bring authentic folk flavor to a wide array of artistic and craft projects: needlework, fabric and textile design, silkscreen, leatherwork, wood burning, and more. Use the designs as they appear here, or scan them into your computer to reduce or enlarge them, or adapt them in any way you see fit. Ready for immediate practical use, without permission or fee, these time-honored motifs represent an evergreen source of artistic and crafts inspiration.

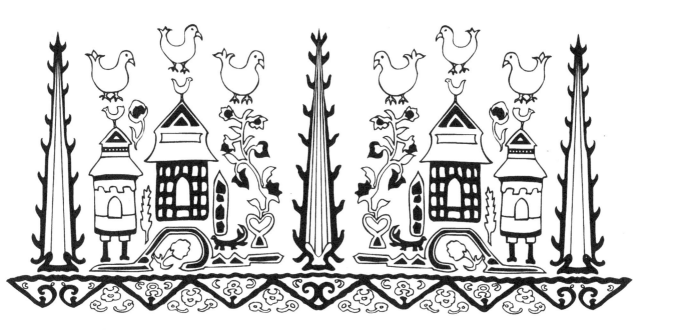

(b)

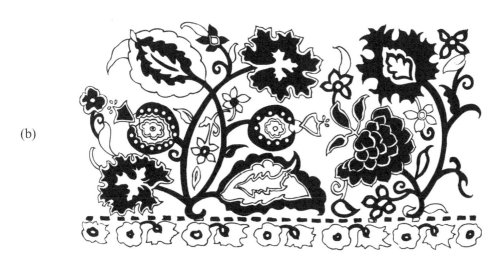

Albania

b) Embroidered borders from ceremonial shawls, vicinity of Berat, north Albania. *(c)* Hem of a coverlet, silk embroidery.

1

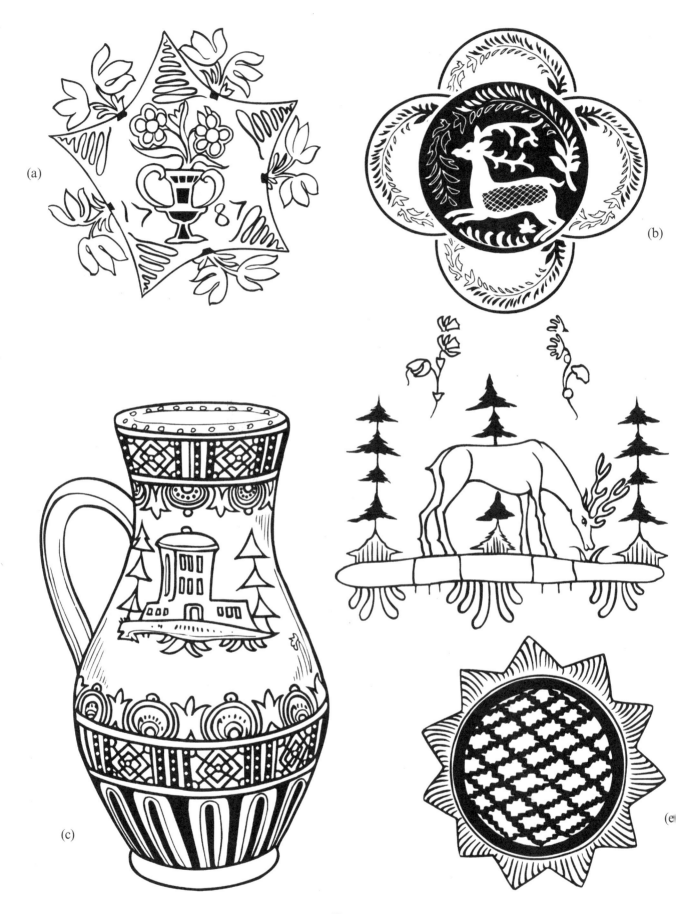

(a)

(b)

(c)

(e)

Austria

(a) Onion bowl, Linz region, upper Austria (1787). *(b)* Motif from a plate (1900s). *(c)* Wine jug, upper Austria (18th centu
(d) Design from a bowl, southern upper Austria (18th century). *(e)* Design from a plate, Styria, Austria (18th–19th century

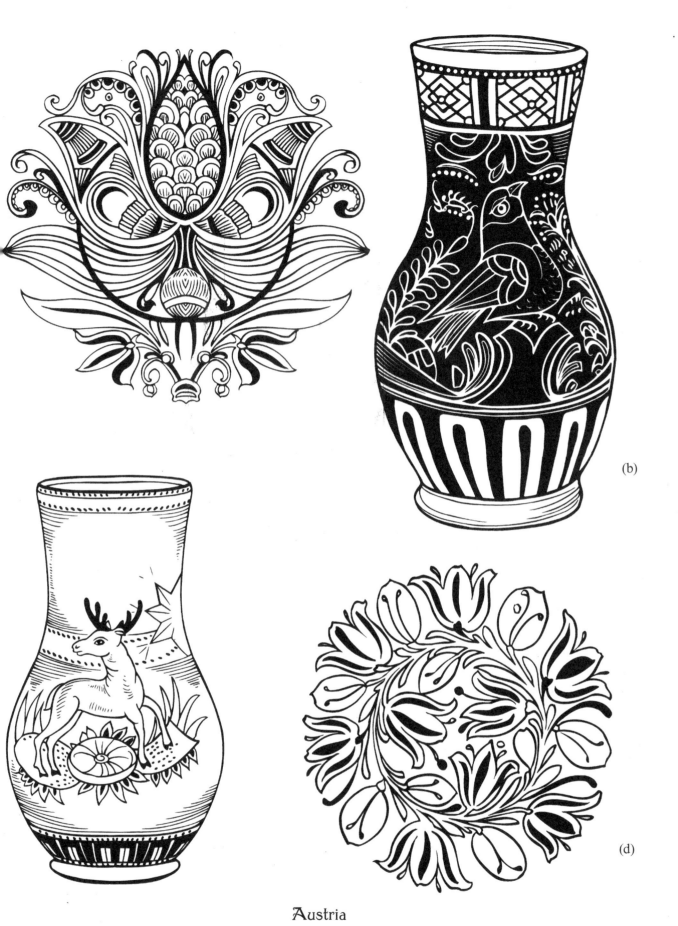

Austria

(a) Plate design (18th–19th century). *(b–c)* Wine jugs, upper Austria (18th century). *(d)* Bowl design (18th century).

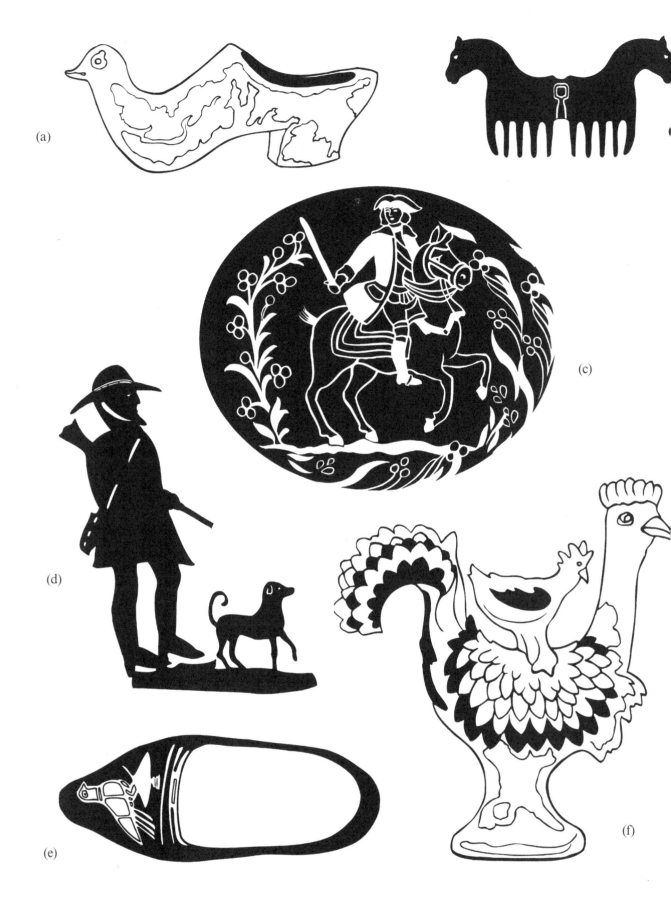

Belgium

(a) Ornamental painted wooden shoe, Antwerp (19th century). *(b)* Curry comb of brass, Flemish (19th century).
Horseman on plate, Thourout (1781). *(d)* Signboard of an inn, iron plate, Flemish (1800). *(e)* Ornamental painted woo[d]
shoe, Antwerp (19th century). *(f)* Painted clay statue of rooster (1800s).

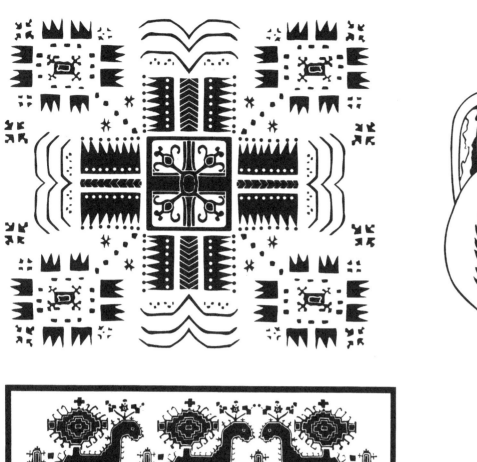

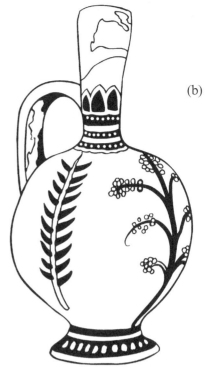

(b)

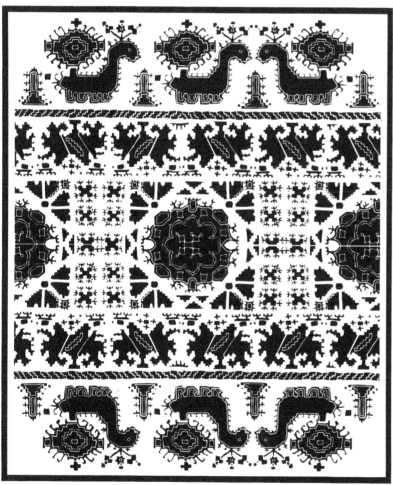

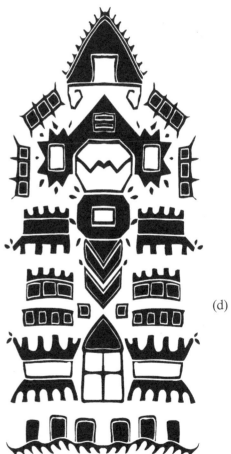

(d)

Bulgaria

Sleeve embroidery, woman's shirt, Dupnica and Grahovo territory (18th century). *(b)* Glazed water jug, Sophia. *(c)* ...ve embroidery, woman's shirt, vicinity of Grohovo (18th century). *(d)* Sleeve and cuff embroidery, woman's shirt, ...nia vicinity (19th century).

5

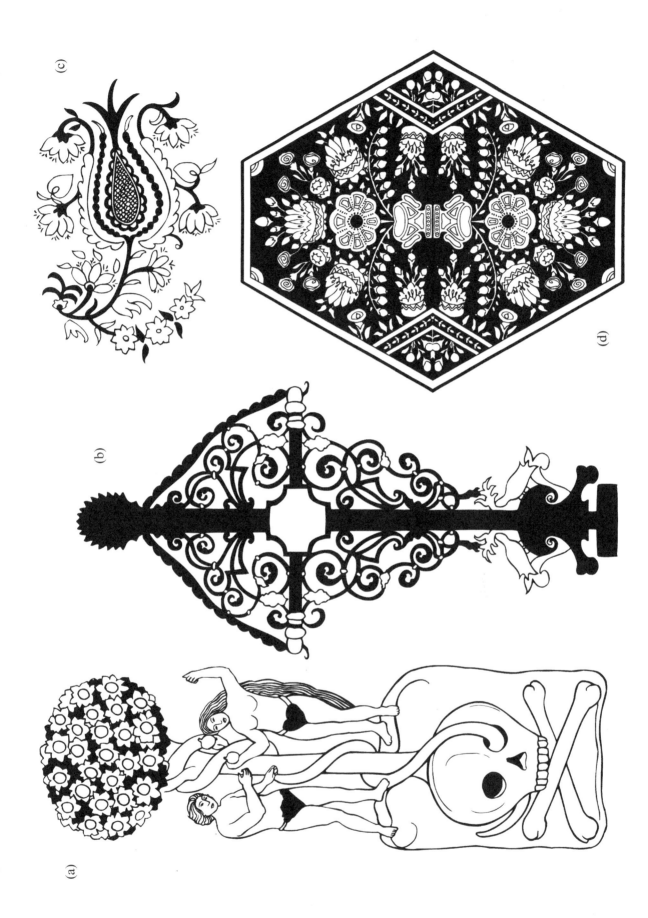

Czechoslovakia

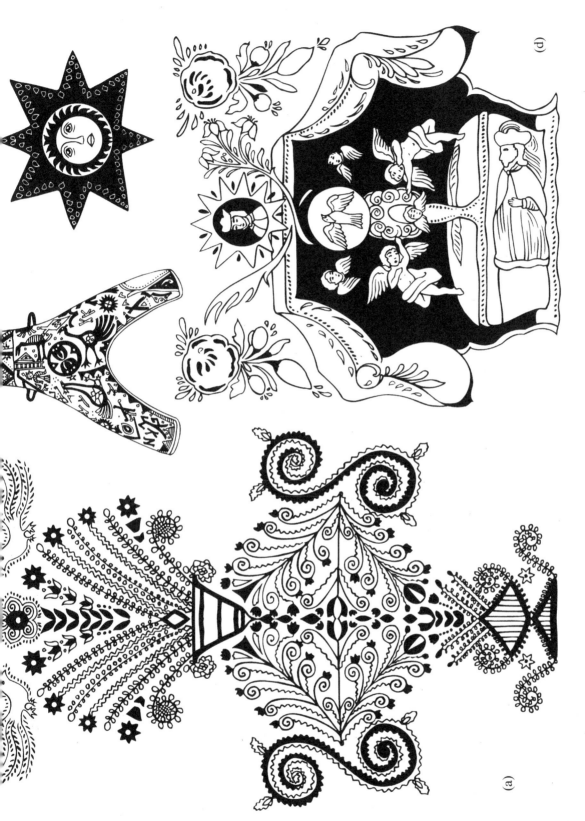

Czechoslovakia

(a) Back of man's jacket, cloth with silk embroidery, Obrava, northern Dalmatia, Yugoslavia. (b) Hunter's powder horn, relief in stone with colored engraving, central Slovakia (18th century). (c) Detail of stamped metal design. (d) St. John of Nepomuk in the grave; painting under glass, patterned after silver gravestone.

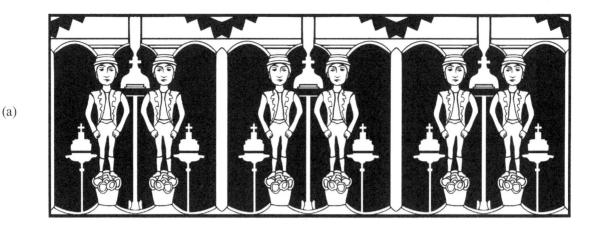

(a)

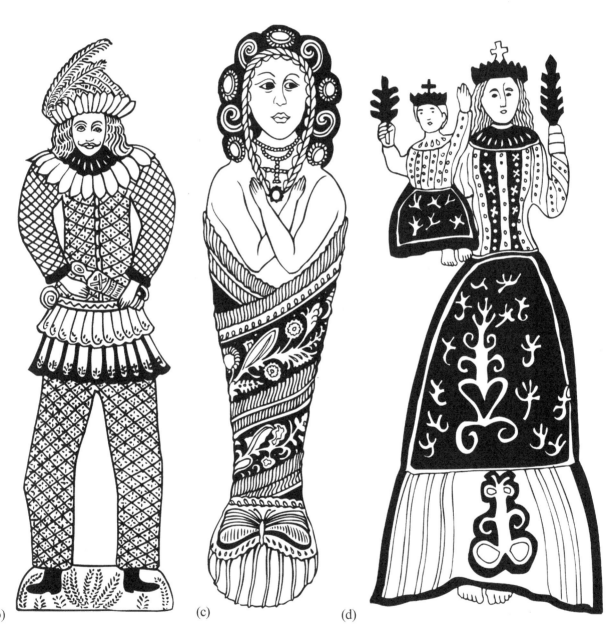

(b)　　　　　　　　(c)　　　　　　　　(d)

Czechoslovakia

(a) Men with hats, polychrome relief from a beehive, Zeleznice, north Bohemia (1880). *(b)* Pierrot, wooden gingerbr
mold (19th century). *(c)* Baby, wooden gingerbread mold, northeastern Bohemia (18th century). *(d)* Madonna with sp
carved wooden statue, Pstruzi, eastern Moravia (18th century).

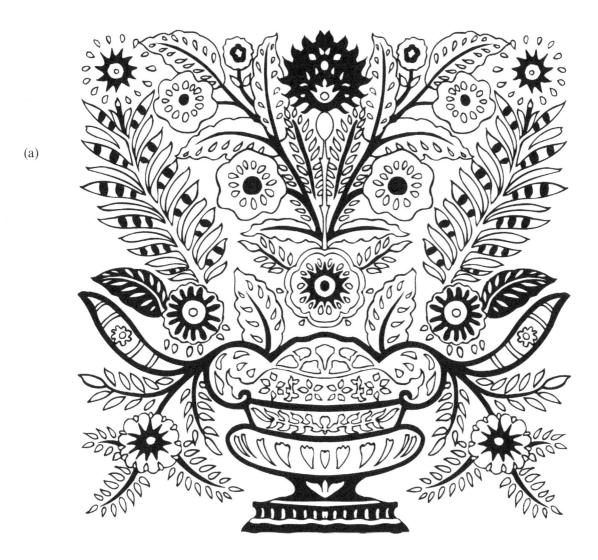

(a)

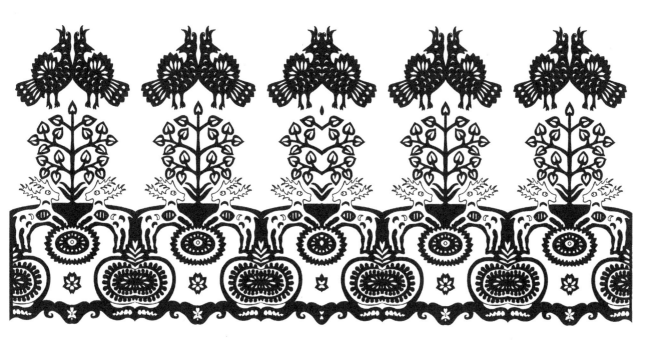

Czechoslovakia

Painted motif, chest, Kostic, near Breclava (1862). *(b)* Motif of deer and birds carved on a wooden blueprint pattern
th century).

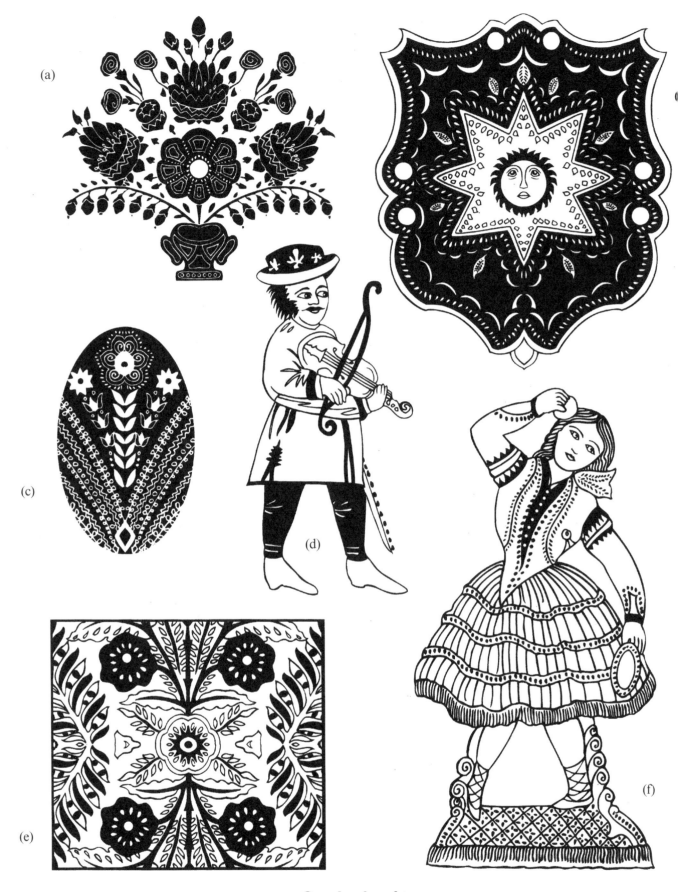

Czechoslovakia

(a) Headboard design, southern Moravia (19th century). *(b)* Stamped metal design. *(c)* Detail of a painted chest (1[...] century). *(d)* Figure of a Hungarian musician by Czech artist (early 1900s). *(e)* Painted motif, wooden chest, Kostic, n[...] Breclava (1862). *(f)* The Spanish Dancer (Pepita de Olivia), wooden gingerbread mold (1855).

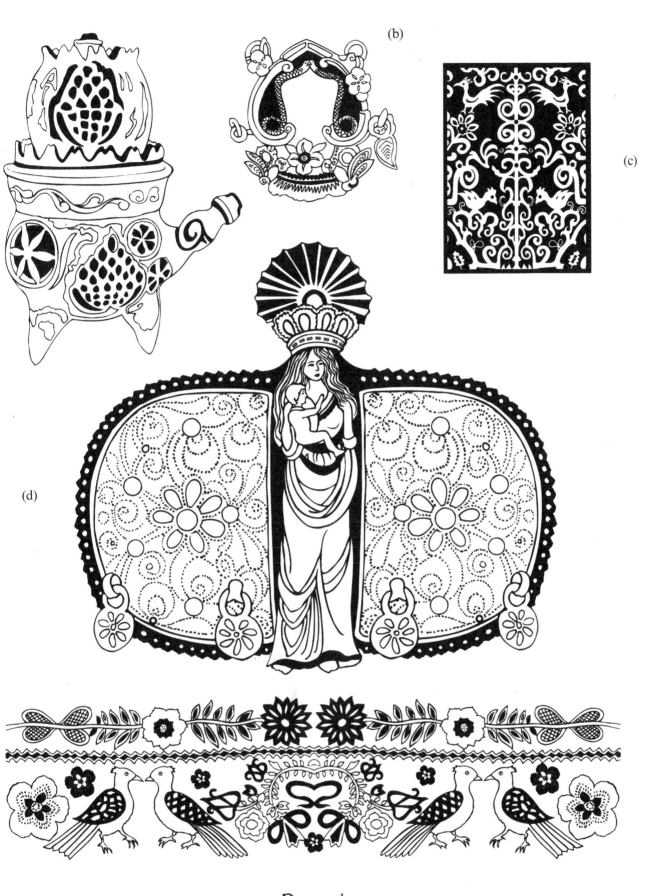

Denmark

Double container for keeping children's food warm, Holbaek (1759). *(b)* Silver hat buckle, Laeso (1800). *(c)* Detail woolen coach blanket. *(d)* Breast ornament and front clasp, gilded silver, Amager (early 19th century). *(e)* Section of roidered bench cover, County Copenhagen (1817).

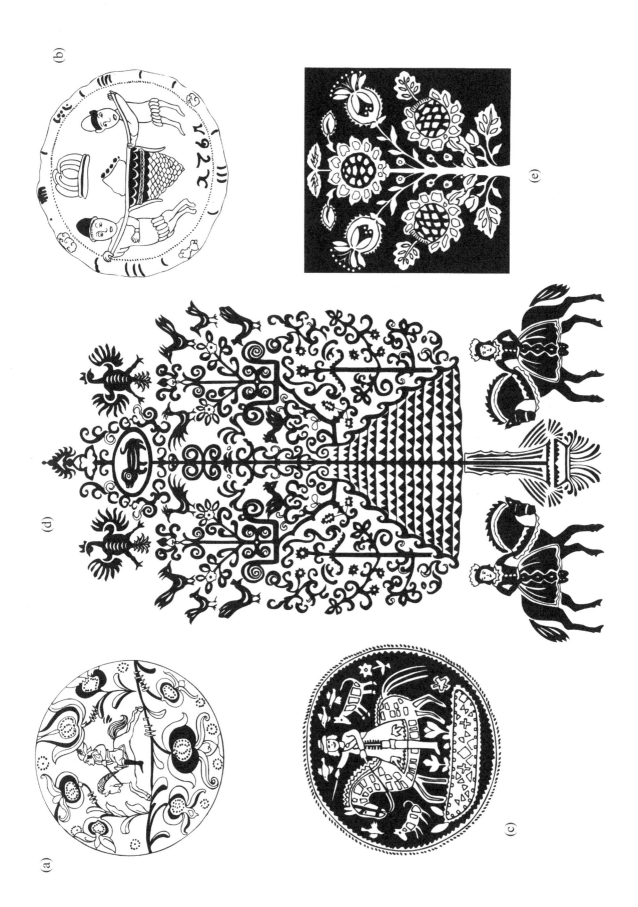

Denmark

(a) Plate, Holbaek district, Sealand (second half of 18th century). (b) Bowl, Aarhus district, Jutland (1761). (c) Section of embroidered

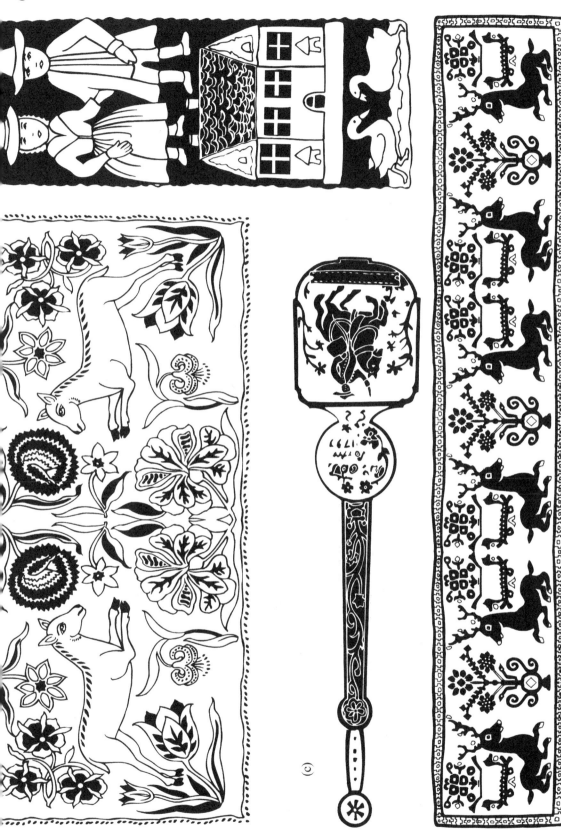

Denmark.

(a) Chair cover, County Holbaek, Sealand (late 18th century). (b) Laundry board, multicolored paint, County Soro, Sealand (1799). (c) Board for ball playing, multicolored paint, Amager (1797). (d) Embroidery, vanity handkerchief, County Frederiksborg, north Sealand (1832).

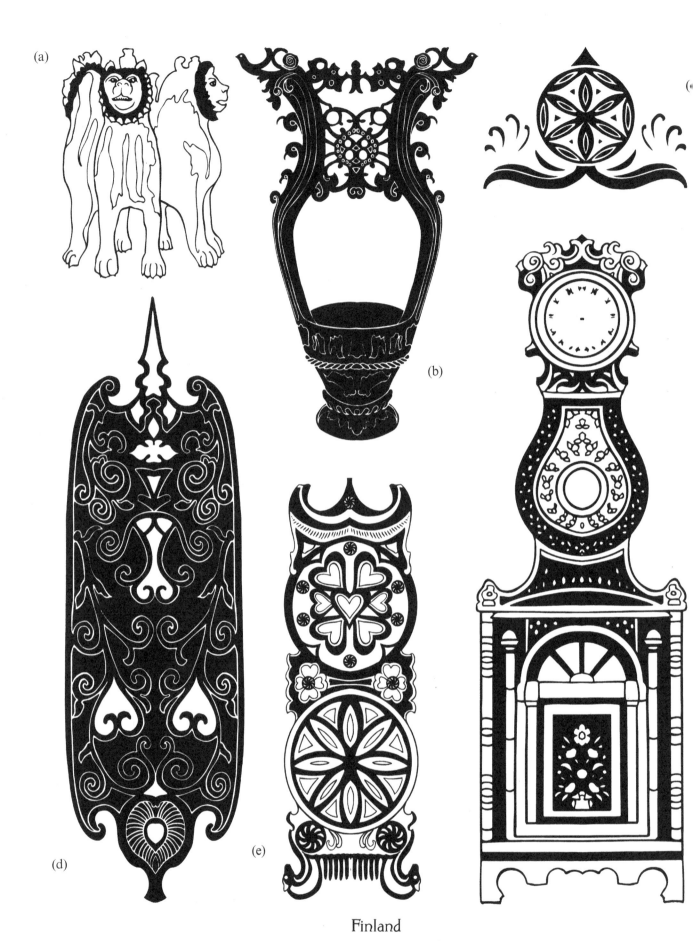

(a)

(b)

(d)

(e)

Finland

(a) Candleholder, Valle, Saetesdalen, south Norway (early 19th century). *(b)* Wooden vessel, Rusko (16th centu
(c) Decorative motif from rullstolar, Vasa Ian (19th century). *(d–e)* Flax holders, Sund (19th century). *(f)* Grandfa
clock, Osterbotten (19th century).

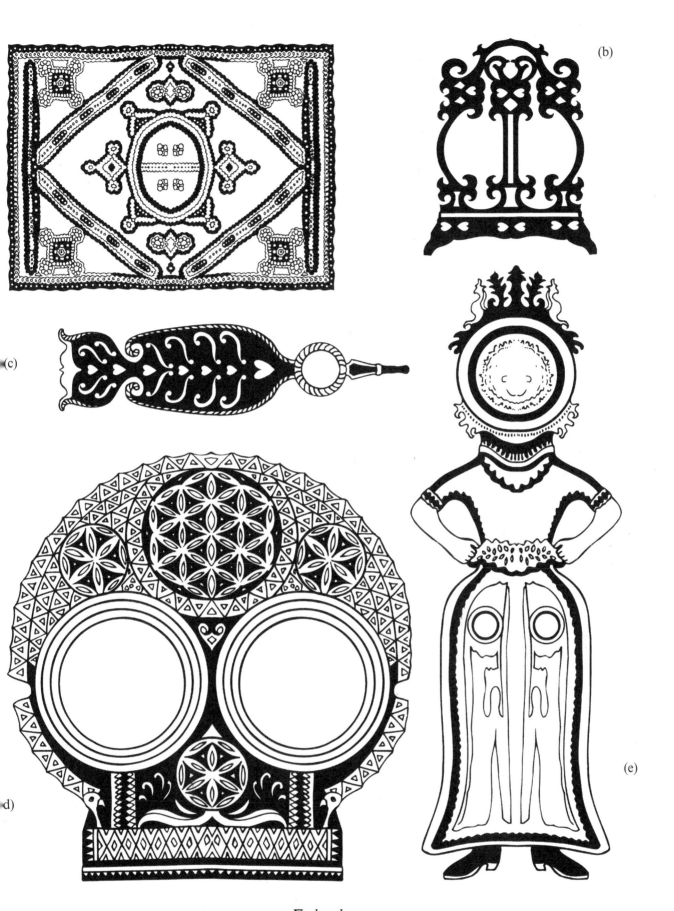

(b)

(c)

d)

(e)

Finland

Pearl embroidery on cloth from a woman's headdress, Finnish Lapland. *(b)* A rullstolar to hold thread, Vasa Ian (19th :ury). *(c–d)* Flax holders, Sund, (19th century). *(e)* Carved clock case, Osterbotten (19th century).

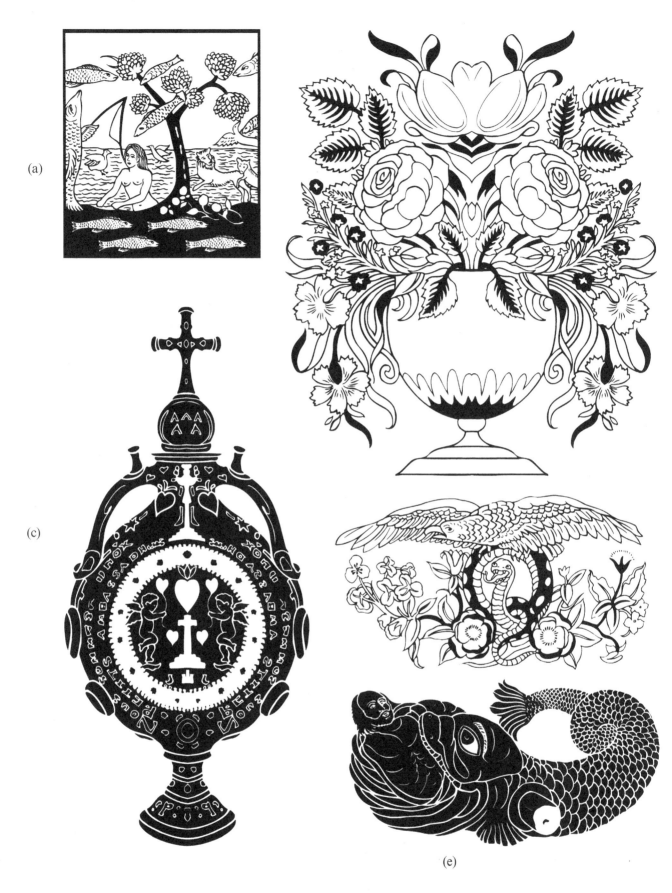

(a)

(c)

(e)

France

(a) Detail from *The World Turned Upside Down,* carved wood, Le Mans (late 18th century). *(b)* Bouquet, painted be[?]
wood, Alsace (1830–1840). *(c)* "Fountain" water jar, glazed earthenware (1828). *(d)* Tattoo design, painted silk ([?]
century). *(e)* Carved decorative element on wooden cask, Alsace (1750).

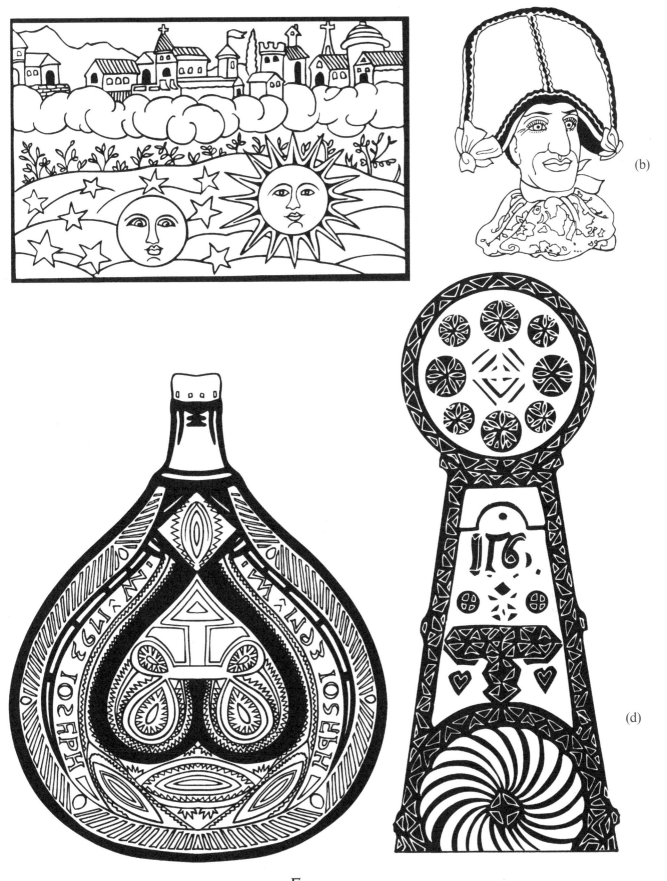

France

Detail from *The World Turned Upside Down,* carved wood, LeMans (late 18th century). *(b)* Puppet head of wood, iron, cloth (early 1900s). *(c)* Powder flask, incised boxwood and iron studs, western France (1793). *(d)* Stele from Bardos eyard, geometric sawtooth designs, circles with radials and stars, Labourd region (1761).

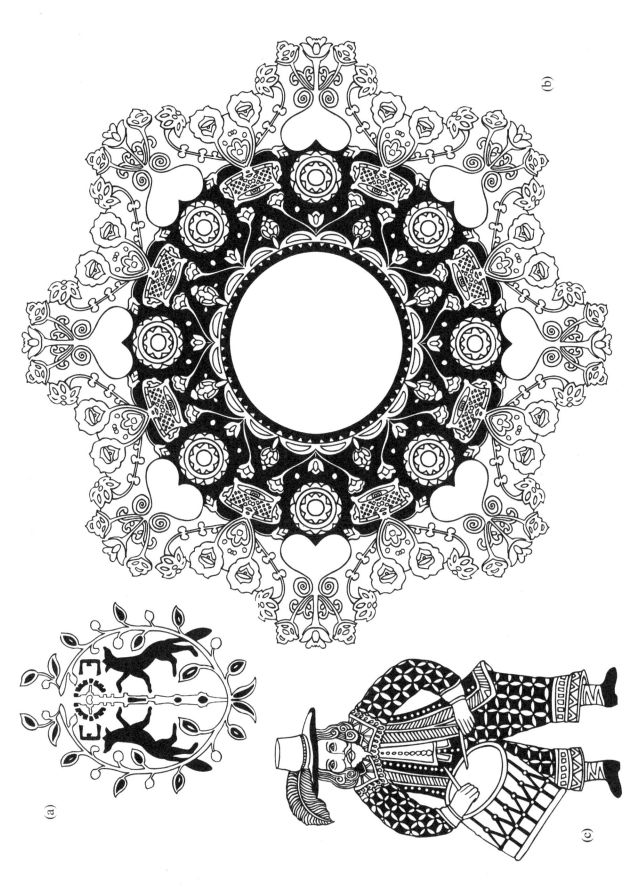

France

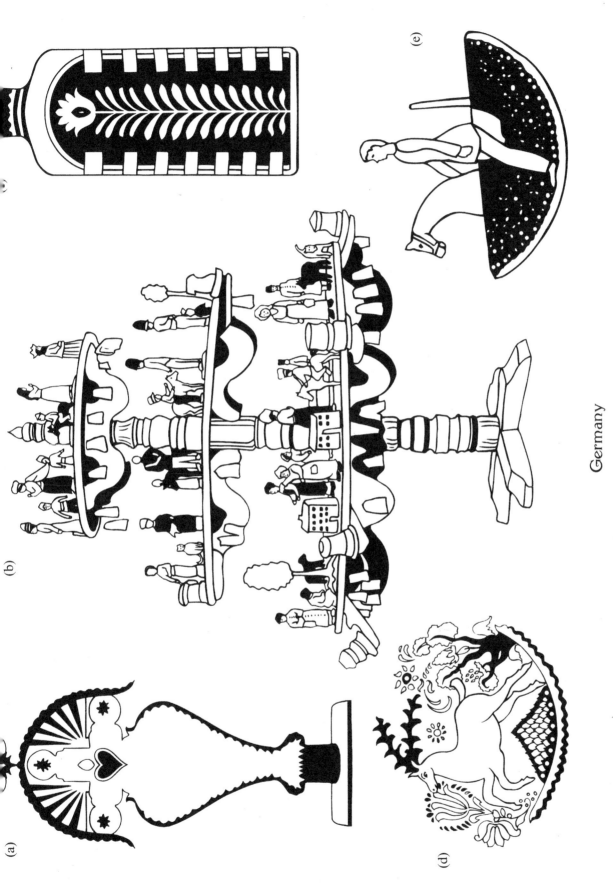

Germany

(*a*) Painted wooden cross with tin roof, Neuwernsdorf (1814). (*b*) Festive candleholder centerpiece for Christmas, Saxony. (*c*) Earthenware vessel, Rhenish (17th–19th century). (*d*) Deer motif, glazed earthenware bowl, Winsener Marsh (18th century). (*e*) Small carved and painted rocking horse, vicinity of Seiffen, Erzgebirge (19th century).

19

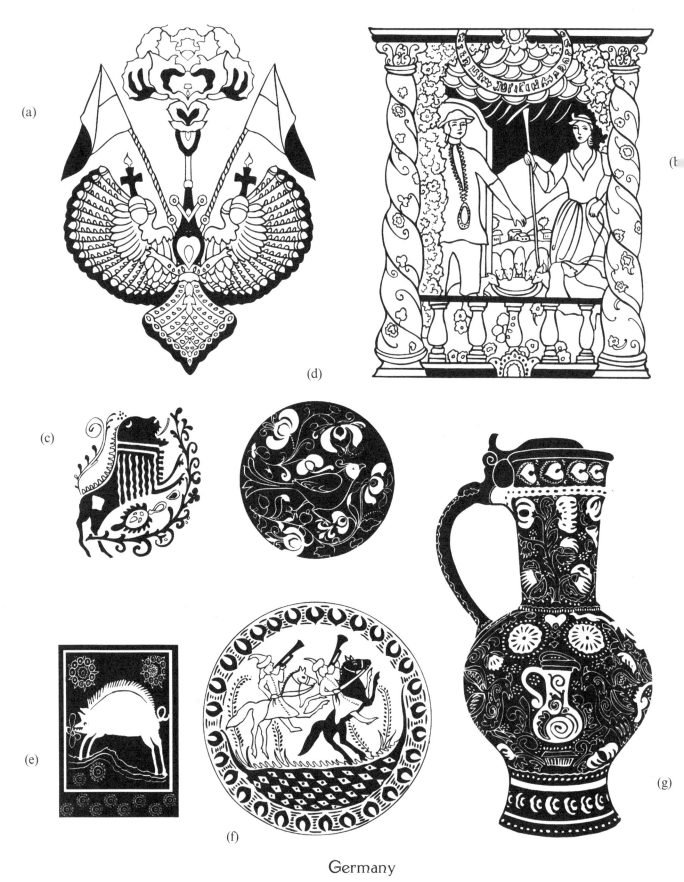

(a)

(b)

(c)

(d)

(e)

(f)

(g)

Germany

(a) Painted archery target in wood with Saxon emblems; flags, feather bush over a crown, Saxony (early 190
(b) Wardrobe door depicting Jacob and Rachel, border region of Saxony and Bohemia (1783). *(c)* Design from earth
ware vessel, Rhenish (17th–19th century). *(d)* Design from glazed earthenware bowl, Winsener Marsh (18th century).
Floor tile from Calw district (1790). *(f)* Horseman on a plate, Rhenish Palatinate (1736). *(g)* Earthenware jug with pew
lid, lower Rhine region (17th century).

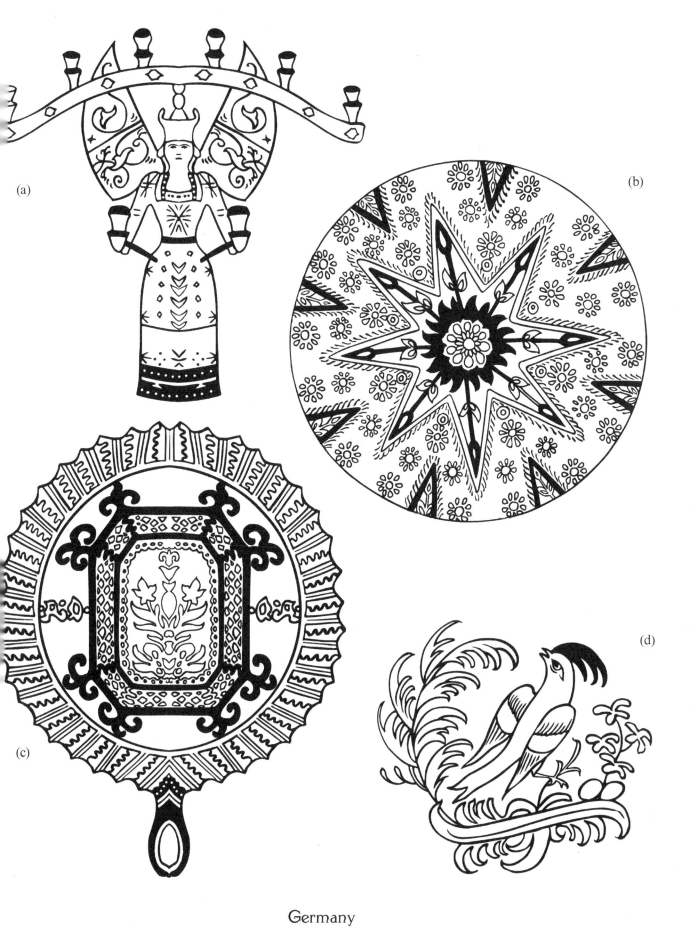

(a)

(b)

(c)

(d)

Germany

Carved wood angel candleholder, Erzgebirge, Saxony (19th century). *(b)* Lid of painted wooden box, Berchtesgaden, Bavaria (19th century). *(c)* Painted wooden cake platter, Lausitz (19th century). *(d)* Design from a plate, Alsace (18th century).

21

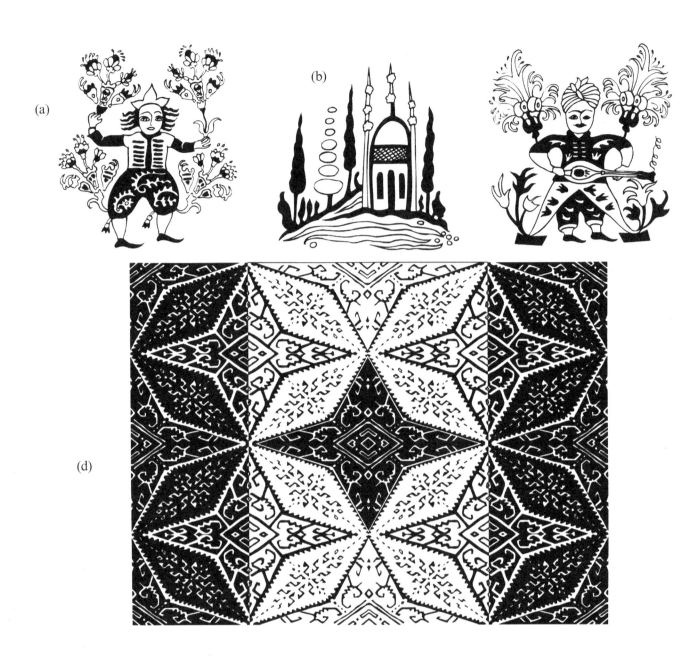

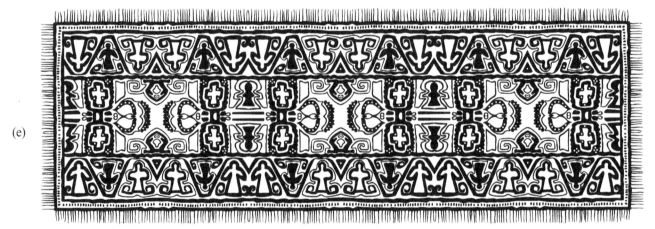

Greece

(a & c) Details from silk embroidery on linen tablecloth (19th century). *(b)* Detail from plate design, Dardanelles (ea[rly] 1900s). *(d)* Silk embroidery on linen drape (18th–19th century). *(e)* Silk embroidery from sleeve of woman's chem[ise] (19th century).

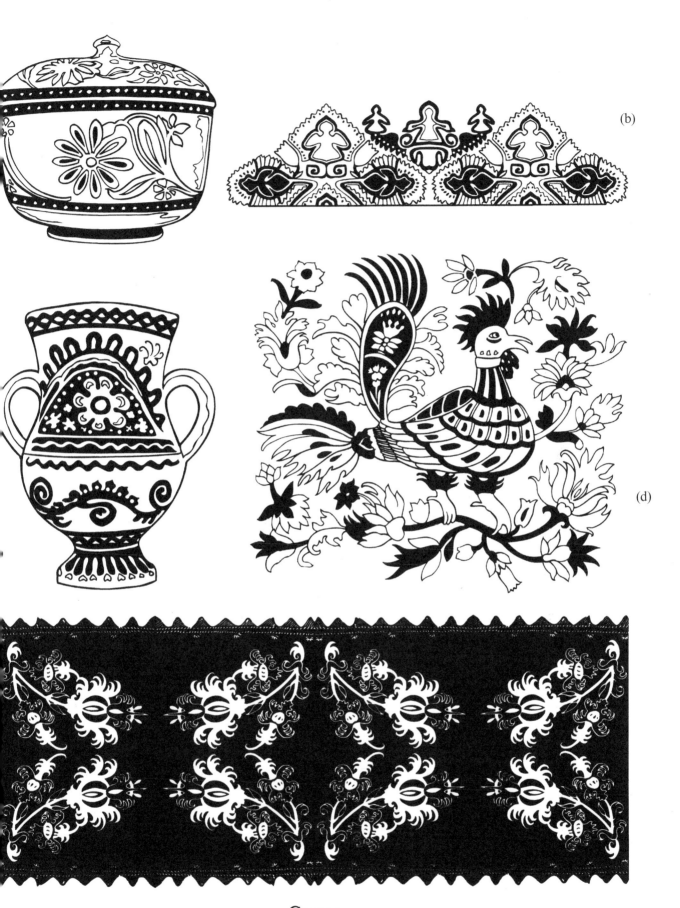

(b)

(d)

Greece

Bowl with lid from the Greek Dardanelles (early 1900s). *(b)* Silk embroidery from sleeve of woman's chemise (19th ury). *(c)* Unglazed vessel with white paint, Skyros (19th century). *(d)* Bird motif embroidered in silk on linen pillow h–19th century). *(e)* Silk embroidery on linen tablecloth (19th century).

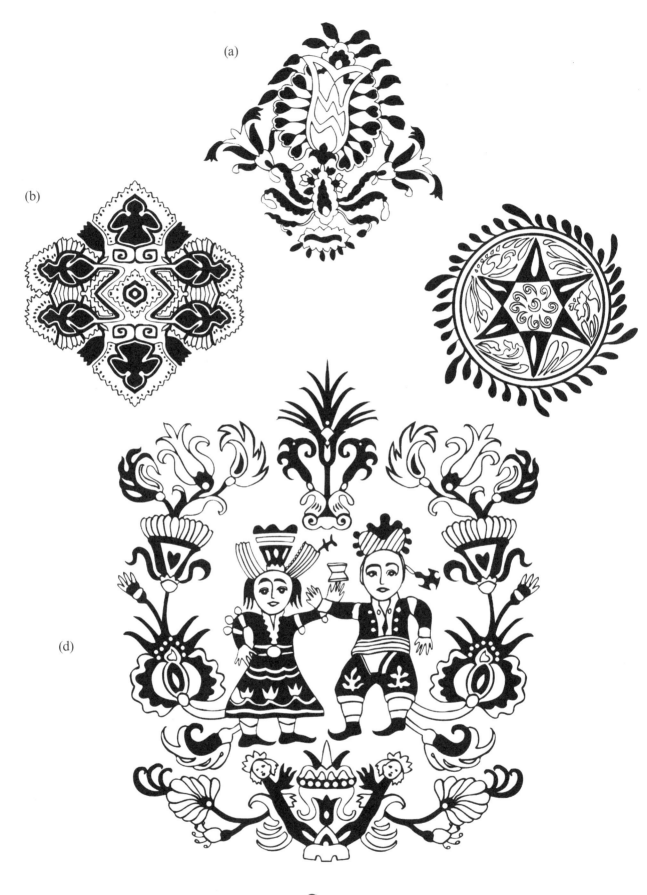

(a)

(b)

(d)

Greece

(a) Silk embroidery on linen sash (18th century). *(b)* Silk embroidery from sleeve of woman's chemise (19th cent[u] *(c)* Plate design, Greek work from the Dardanelles (early 1900s). *(d)* Silk embroidery on linen cloth (18th and centuries).

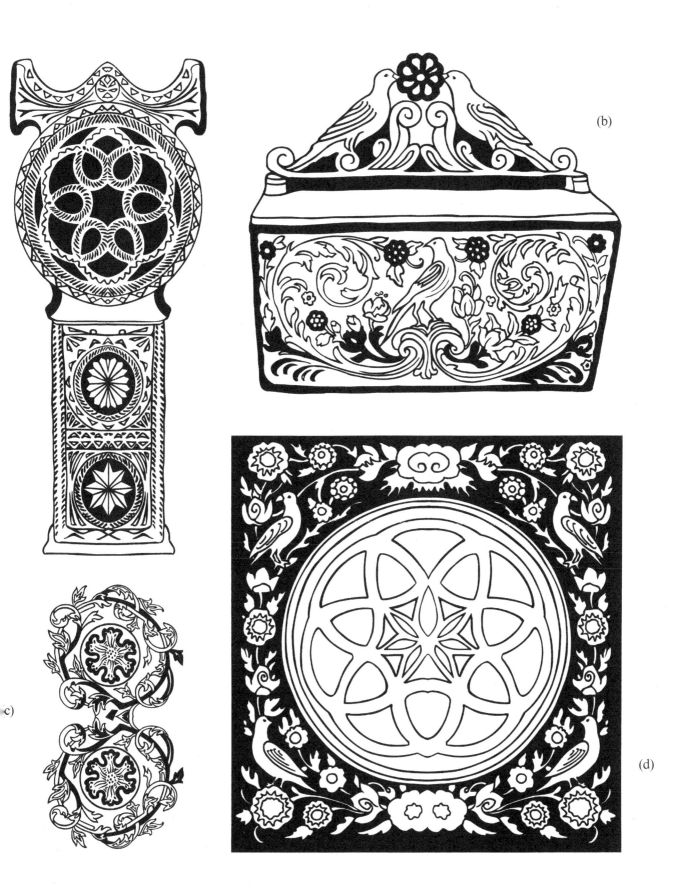

Holland

Base of wooden frame used to raise furniture in case of a flood, Hindenloopen (1737). *(b)* Painted wall box, denloopen (18th century). *(c)* Design from painted wooden plate, Hindenloopen (18th century). *(d)* Painted small den box with metal footwarmer, Hindenloopen (18th century).

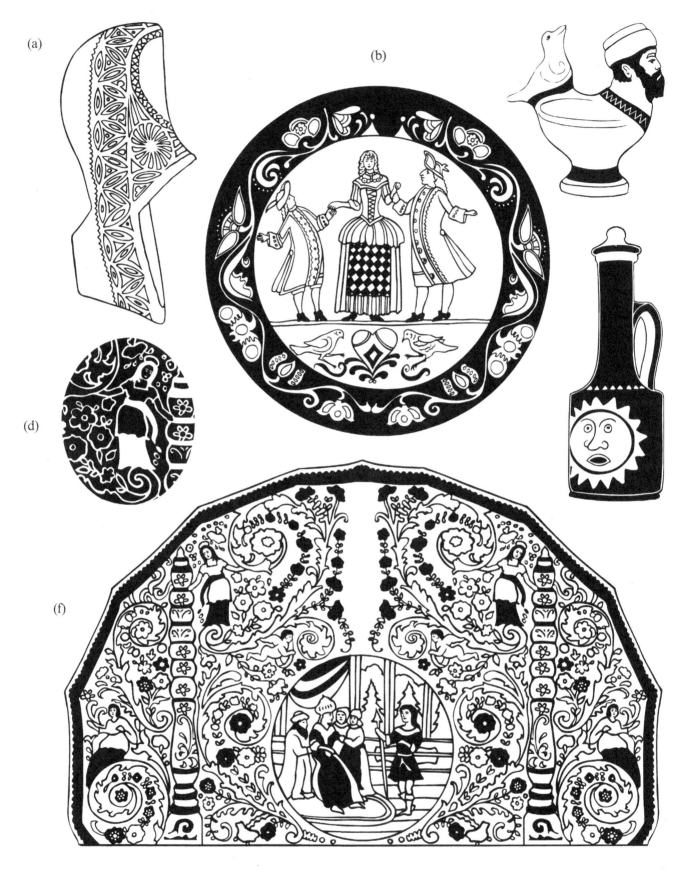

(a)

(b)

(d)

(f)

Holland

(a) Unpainted carved wooden shoe. *(b)* Large platter from Gennup (18th century). *(c)* Painted clay pipe. *(d)* Detail drop-leaf table, Hindenloopen (18th century). *(e)* Small vessel. *(f)* Section of underside of drop-leaf table, Hindenloo (18th century).

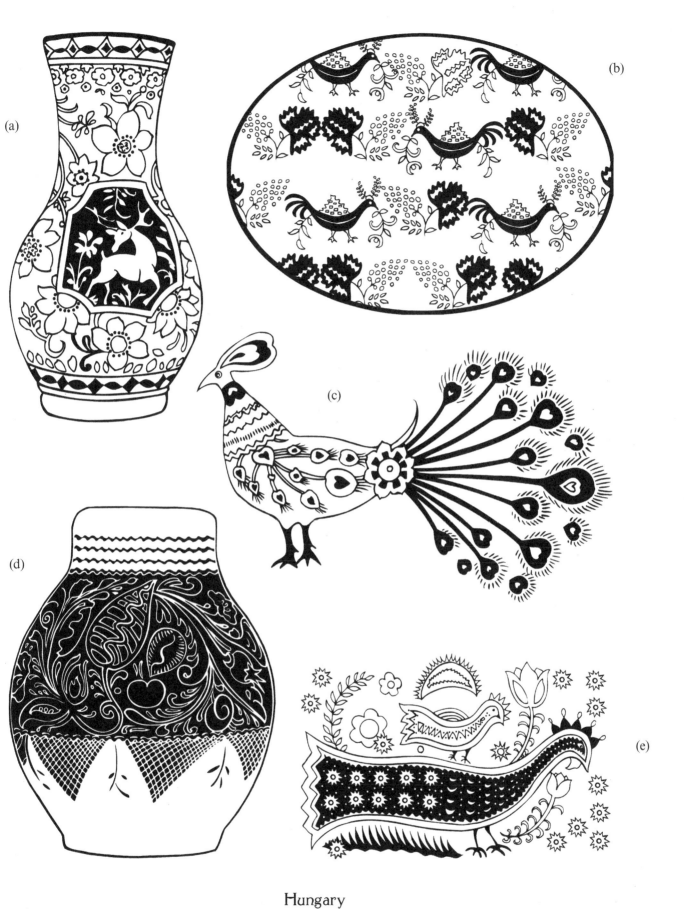

Hungary

Faience ewer, Habaner ware (18th century). *(b)* Sampler embroidery, west Hungary, Slovak influence (early 19th ury). *(c)* Traditional bird motif. *(d)* Faience ewer, Habaner ware (17th century). *(e)* Traditional bird motif.

(a)

(c)

(d)

Hungary

(a) Tile (early 18th century). *(b)* Habanian tile depicting a Hungarian soldier, upper Hungary (18th cent
(c) Traditional bird motif. *(d)* Tile (18th century). *(e)* Section of embroidered bedsheet (early 19th century).

Hungary

(a) Section of embroidery on altar hanging, west Hungary (19th century). (b) Traditional bird motif. (c) Traditional animal motif.

Iceland

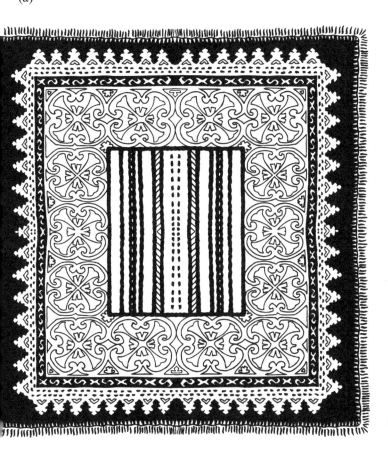

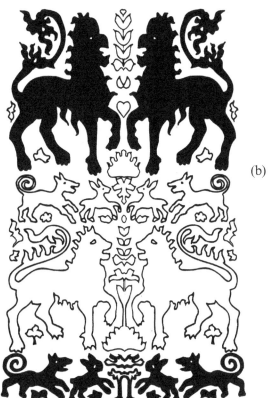

(b)

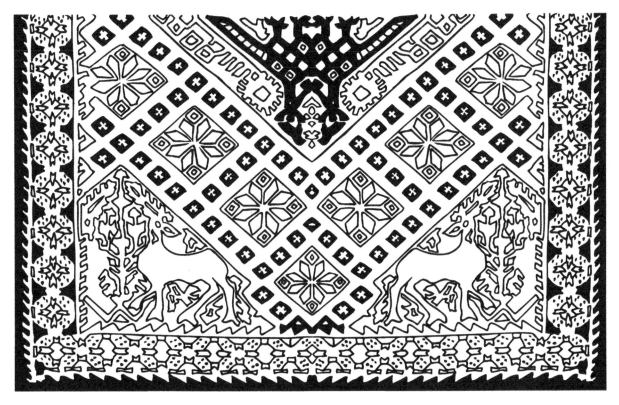

Italy

Rug, Aquila, Pescocostanzo, Abruzzi (19th century). *(b)* Section of rug, vicinity of Aquila, Abruzzi (late 17th century). Section of large rug, Pescocostanzo, Abruzzi (late 18th century).

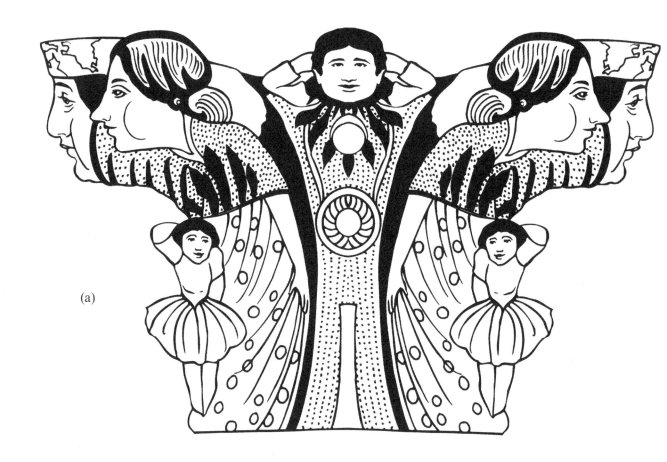

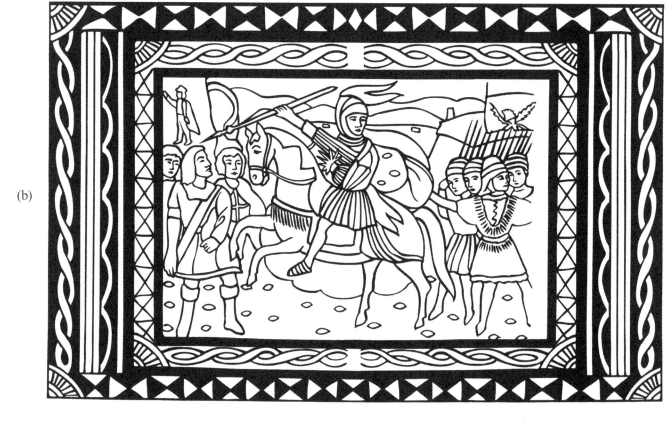

Italy

(a) Woodcarving from rear board of Sicilian cart. *(b)* Lid of wooden box, painted in style of Sicilian carts.

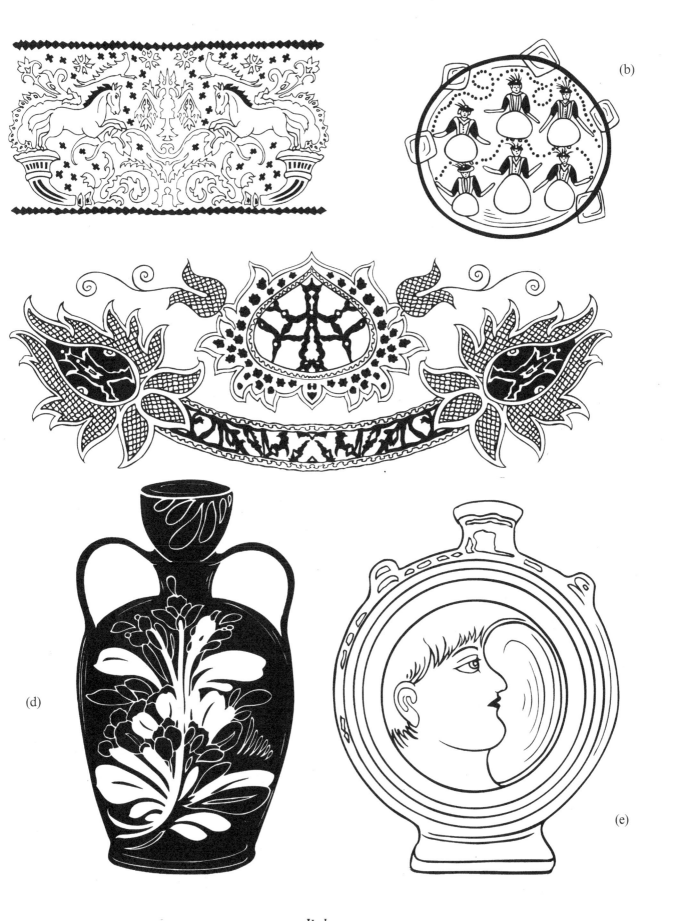

Italy

Mythical animals and birds on detail of antique tapestry (19th century). *(b)* Painted tambourine, Sicily. *(c)* Italian cut-work on linen (early 17th century). *(d)* Wine jar, Abruzzi (19th century). *(e)* Bottle with face motif, Abruzzi (18th century).

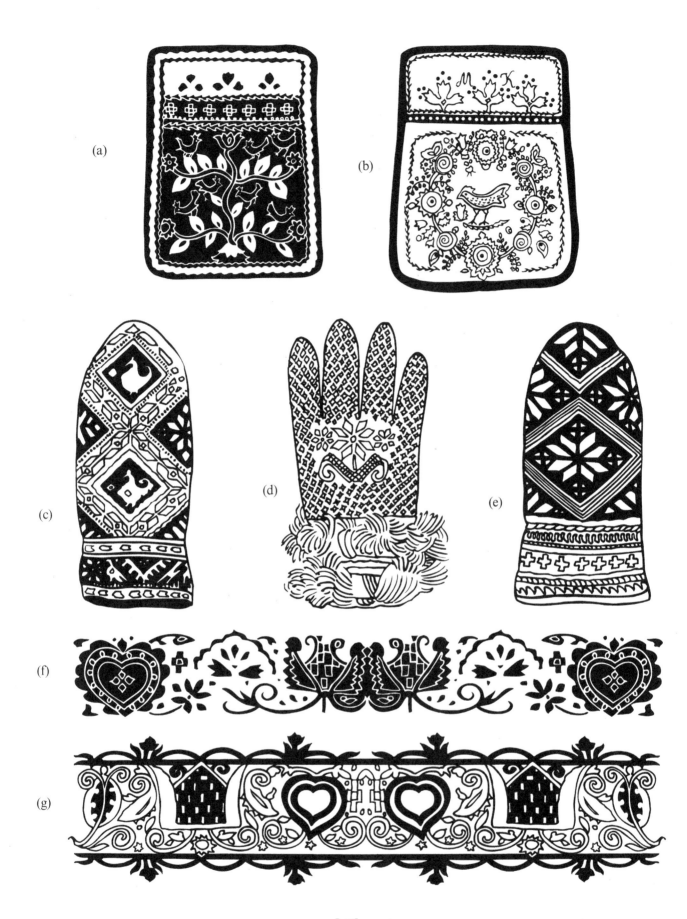

Lithuania

(a–b) Embroidered satchels. *(c)* Mitten. *(d)* Glove. *(e)* Mitten. *(f–g)* Embroidered textile trims. (All early 1900s).

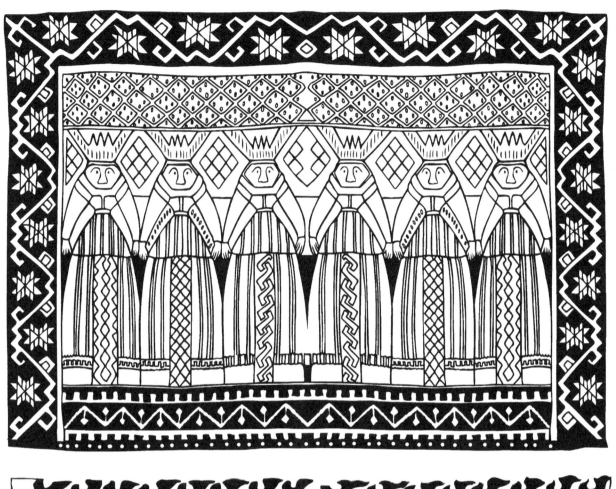

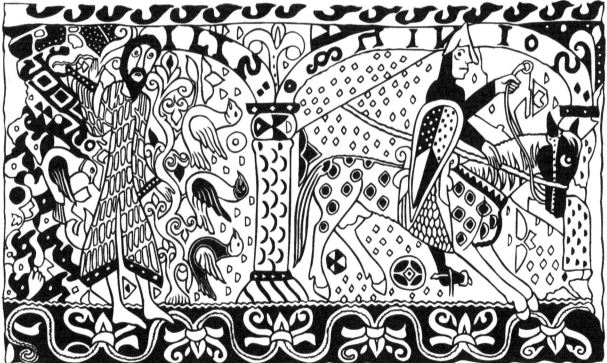

Norway

Tapestry from Sor-Trondelag depicting the Wise and Foolish Virgins (mid-17th century). *(b)* Section of large tapestry
Baldishol Church depicting the months of April and May as a young squire and a young warrior (12th century).

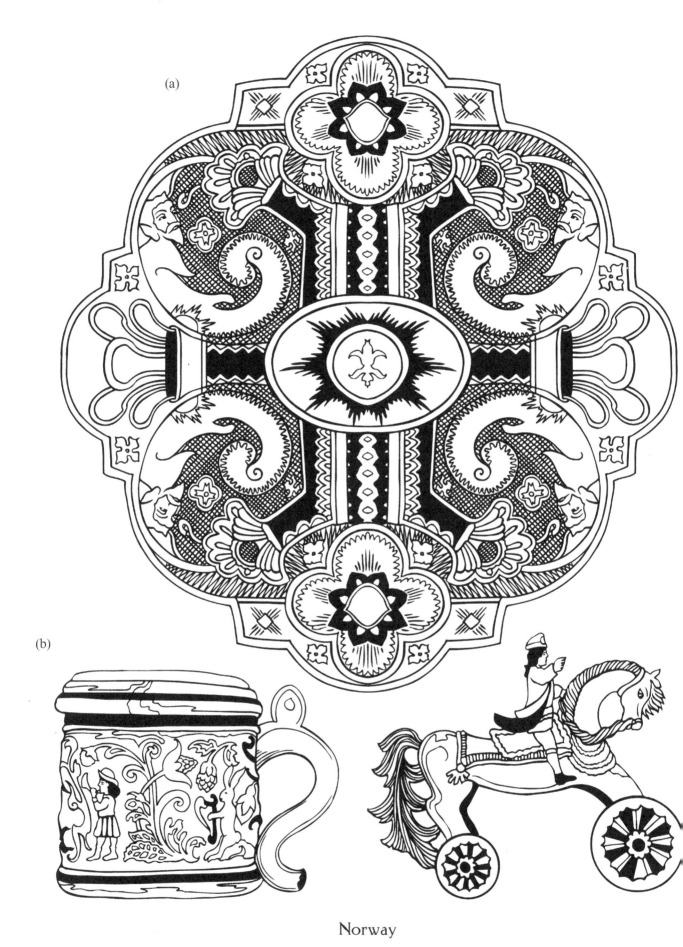

(a)

(b)

Norway

(a) Belt buckle cast in two pieces and soldered together, Hallingdal. *(b)* Wooden beer mug. *(c)* Carved toy h
Lillehammer.

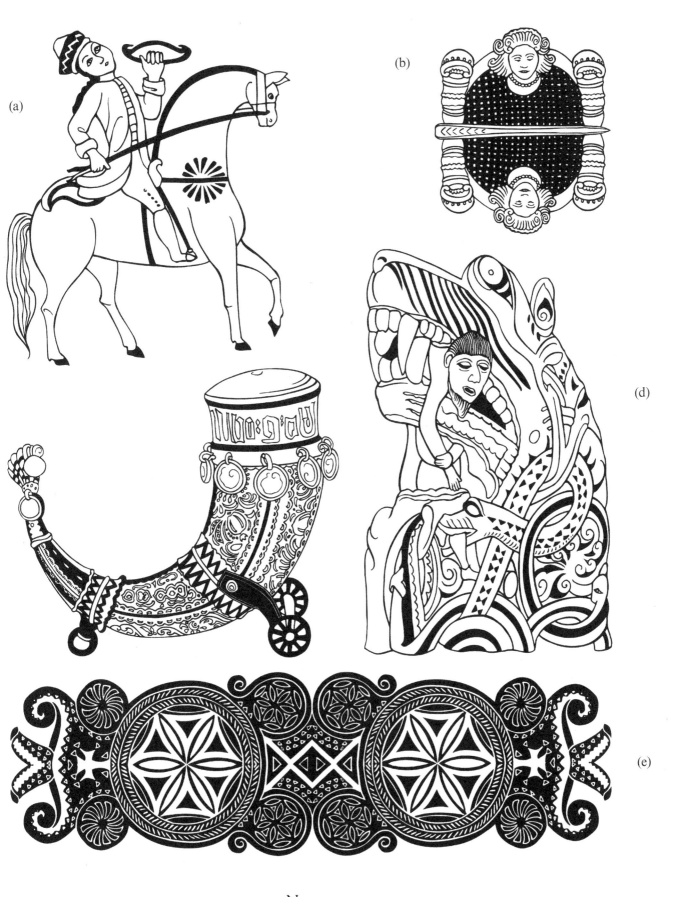

Norway

Detail from door painting (original design from woodcut of a Danish king), Hallingdal. *(b)* Horn ring pin, older type, ~~le~~, Setesdal. *(c)* Drinking horn, Vinje, Telemark. *(d)* Detail of pew from Torpostave Church (man in clutches of a lion), ~~ingdal~~. *(e)* Decorative post on a fire screen from Hardanger.

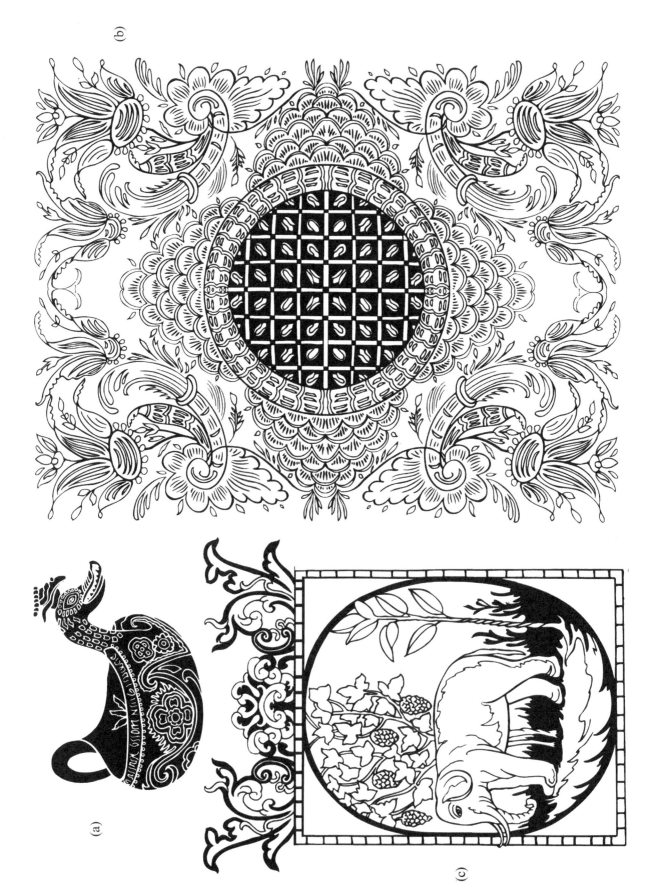

Norway

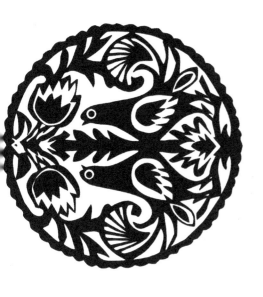

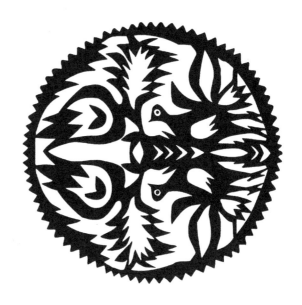

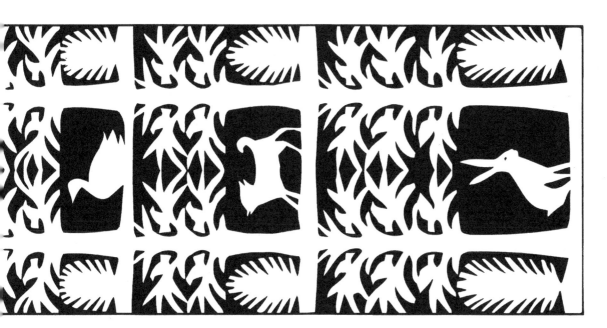

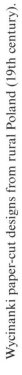

Poland

Wycinanki paper-cut designs from rural Poland (19th century).

(a)

(b)

Poland

(a) Plate design (19th century). *(b)* Painting on glass, in wooden frame (19th century).

Poland

Glass painting, Podhale, Tatra, Poland (early 19th century). *(b)* Polish Wycinanki design (early 19th century). *()* Details from plate design (19th century). *(e)* Majolica stove tile with engraved outline (19th century). *(f)* Wooden *ch* candle chandelier, carved and painted (19th century). *(g)* Majolica stove tile with engraved outline (19th century).

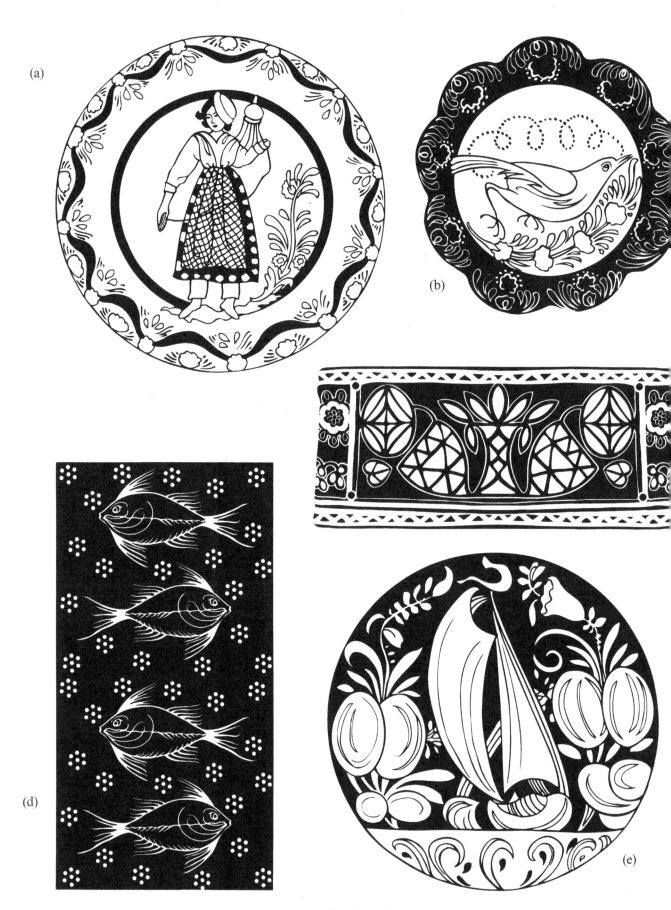

Portugal

(a–b) Plates (18th–19th century). *(c)* Sewing kit, carved from cork and painted (1862). *(d)* Majolica tile or pottery d
with fish motif. *(e)* Large plate with sailing boat and floral motif (17th century).

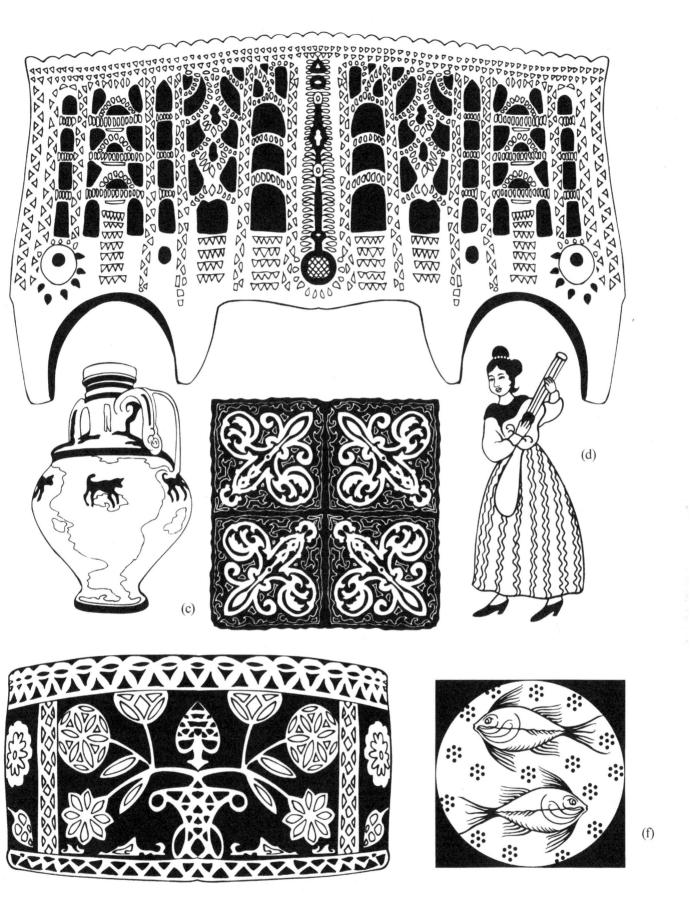

Portugal

Ox yoke, wood carving, Monho, north Portugal (19th century). *(b)* Jug with dog motif (early 1900s). *(c)* Section from embroidered rug (18th century). *(d)* Detail from plate design (18th–19th century). *(e)* Sewing kit, carved from cork painted (1862). *(f)* Detail from majolica tile.

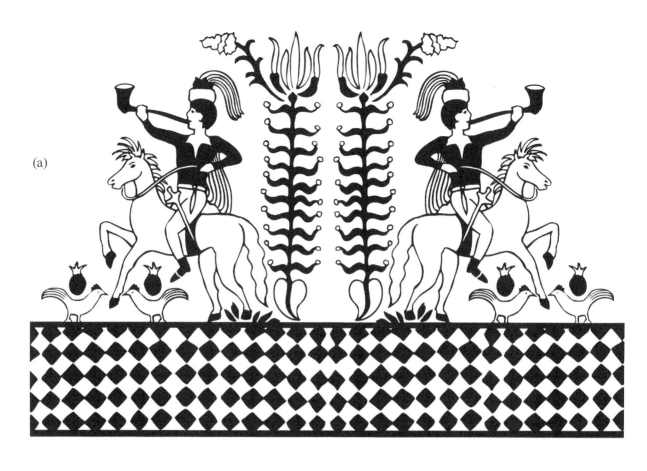

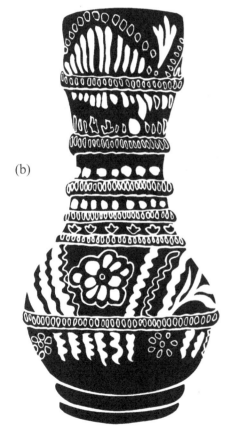

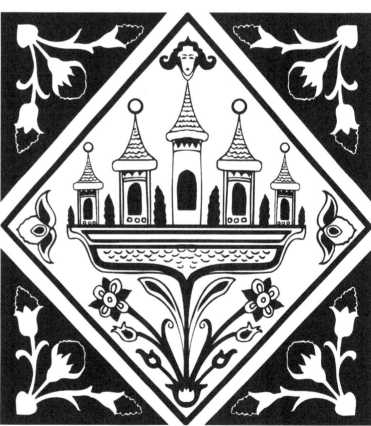

Romania

(a) Tile with green glaze, Transylvania (17th century). *(b)* Pitcher with lead glazing, Saxon work from Transylvania (
century). *(c)* Unglazed tile with coat of arms of Sibiu, Transylvania (early 18th century).

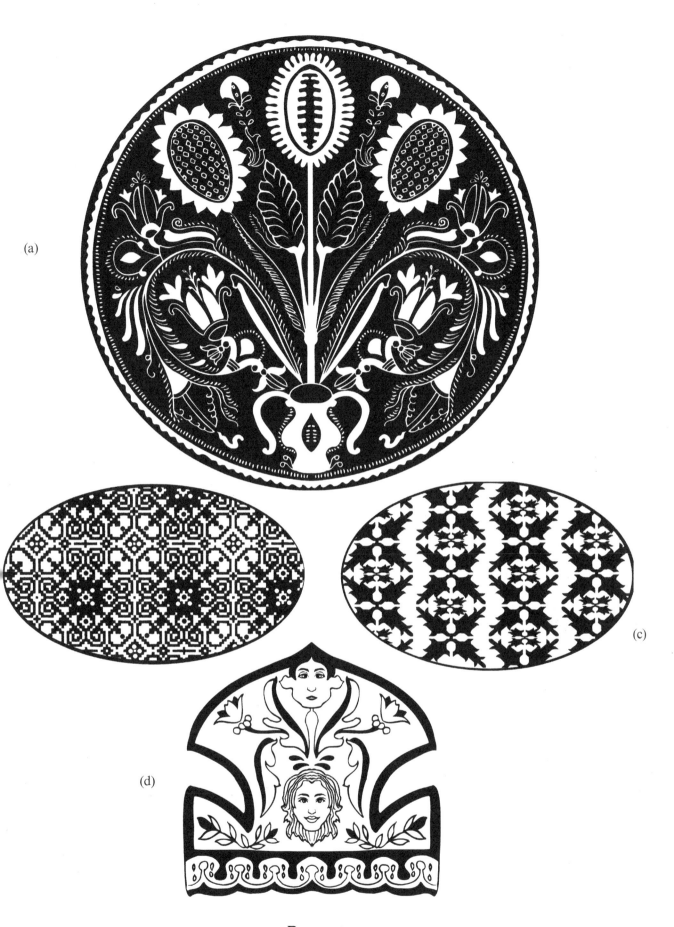

Romania

(a) Large glazed bowl, Transylvania (18th century). *(b–c)* Textile motifs. *(d)* Tile design, Transylvania (18th century).

45

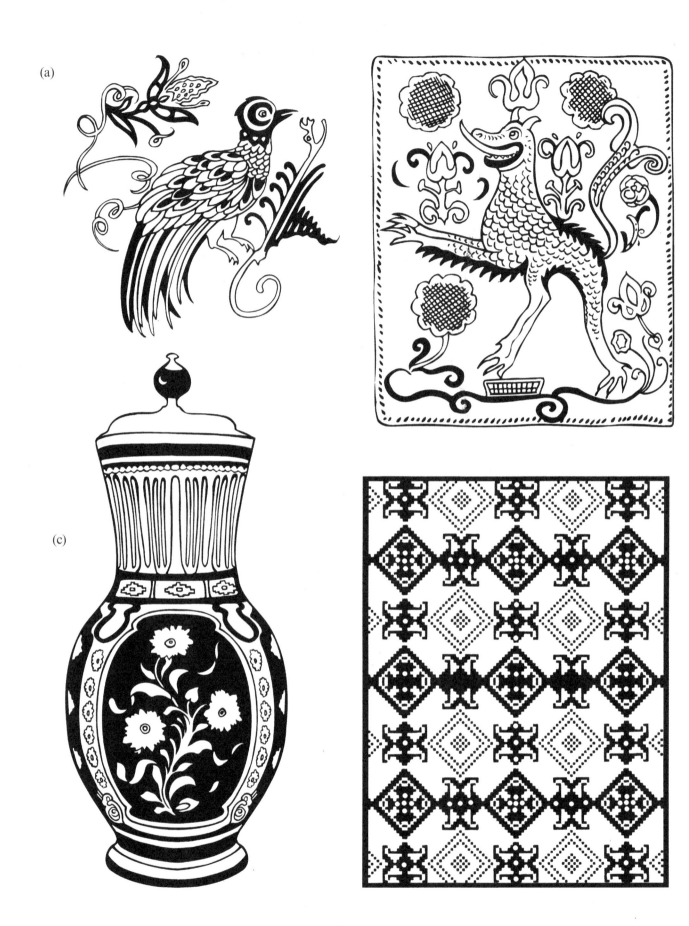

(a)

(c)

Romania

(a) Bird motif from plate decorated in sgraffitto technique (1805). *(b)* Tile with green glaze, Transylvania (17th centu...
(c) Alvincz faience ewer, Transylvania (18th century). *(d)* Decorative textile motif, Muntenia.

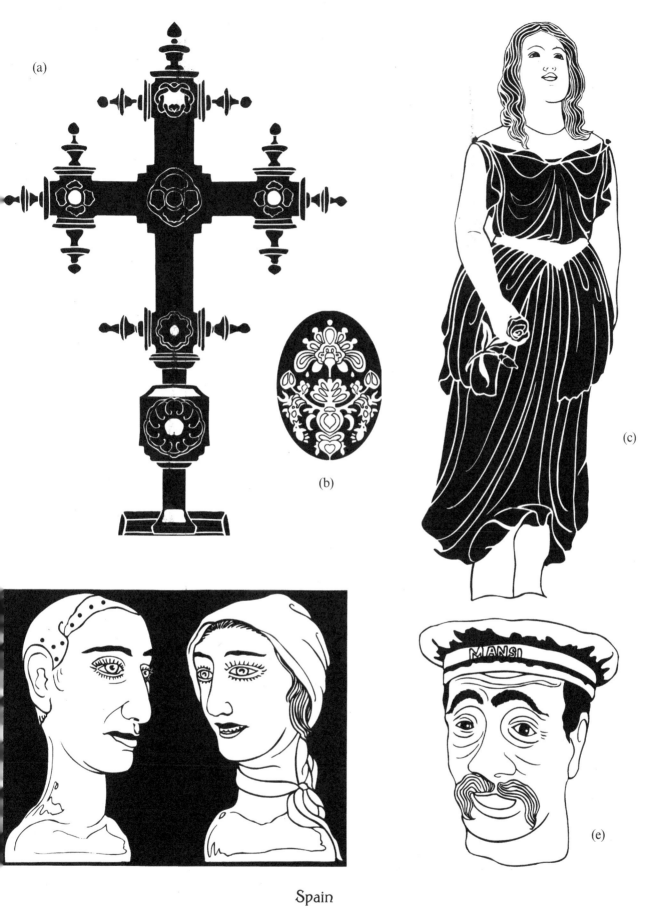

(a)

(b)

(c)

(e)

Spain

Wooden cross (18th century). *(b)* Detail of embroidered handbag (18th century). *(c)* Dona de la Rosa (Lady of the
), polychrome wood figurehead, Barcelona (1900). *(d)* Hand puppets, polychrome wood, human hair, cloth and glass,
luna, (19th century). *(e)* Viejo Cabezudo (Old Big Head), painted papier-mâché, Zaragosa (early 1900s).

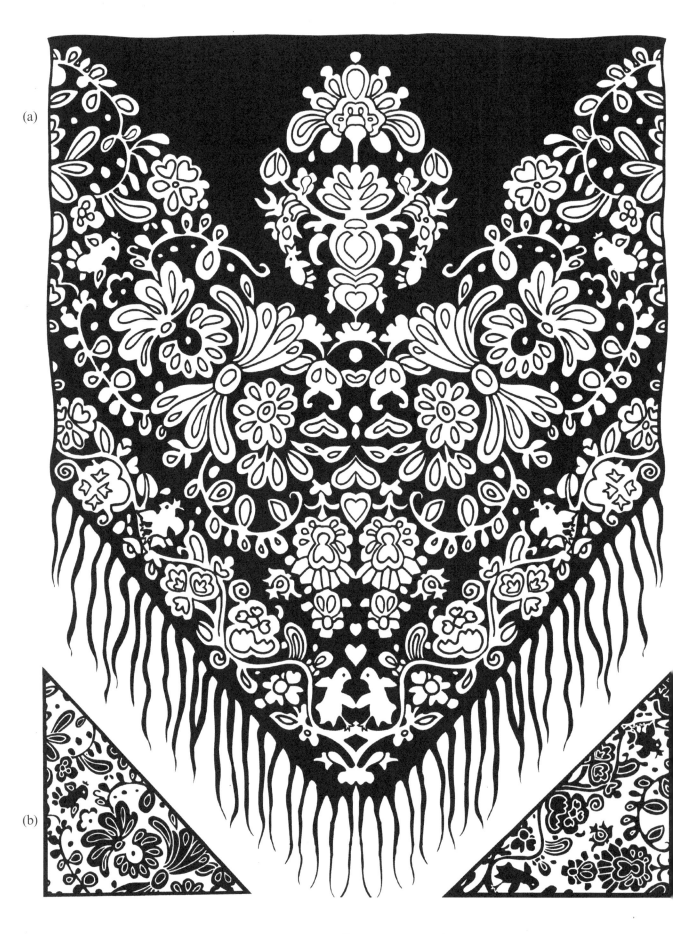

(a)

(b)

Spain

(a) Traditional shawl with wool and silk embroidery, Castile (18th century). *(b–c)* Details of embroidery on shaw

48

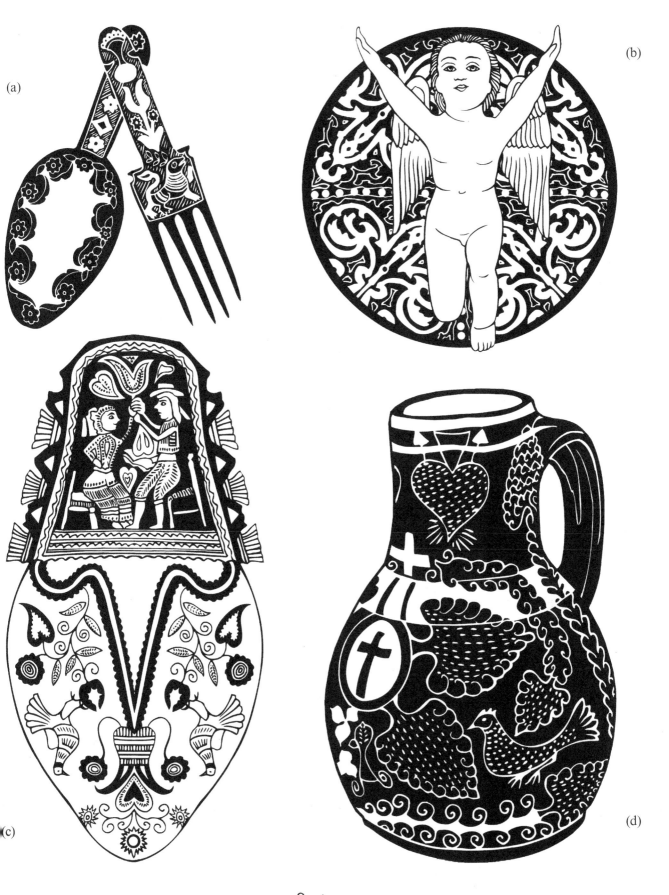

Spain

Spoon and fork with flowers and deer, Salamanca (early 1900s). *(b)* Carved wooden cherub with glass eyes, embroi-
d textile background (18th century). *(c)* Wooden spoon with carved design of a couple, flowers and birds, Salamanca
0s). *(d)* Glazed and incised earthenware pitcher with the symbols of Christ, Palencia (early 1900s).

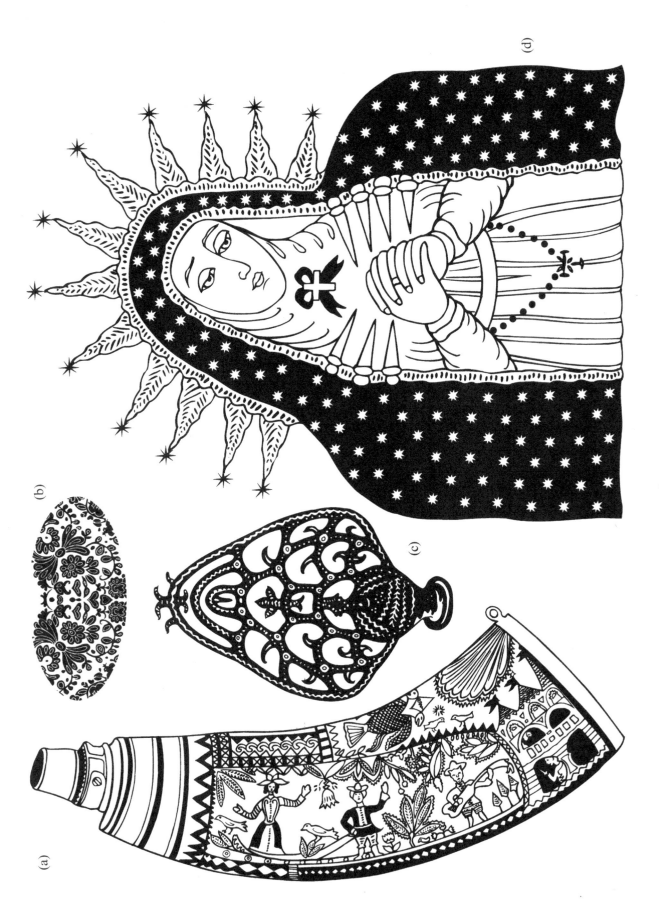

Spain

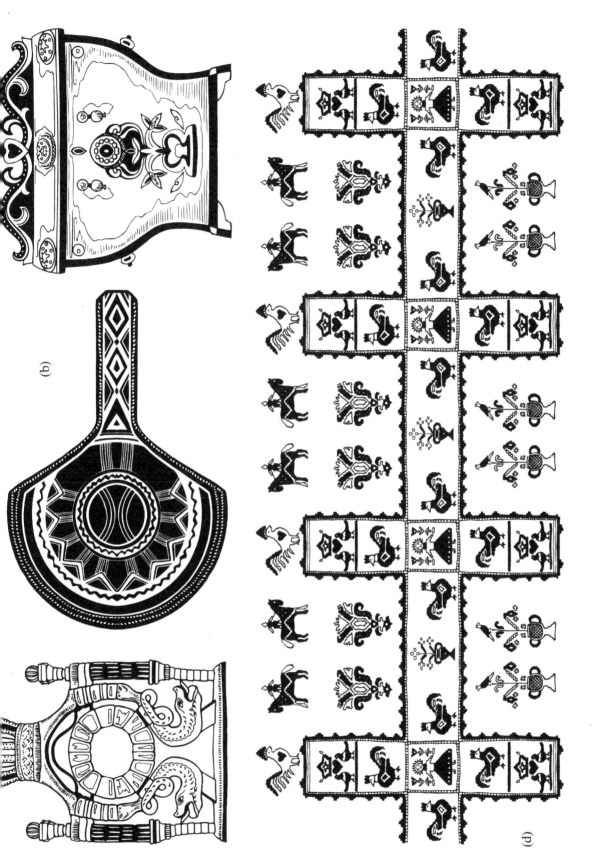

Sweden

(a) Frame to hold a watch, Bohuslan (1800). (b) Ornament carved from bone with incised design, Swedish Lapland. (c) Small box, Vasterbotten (early 19th century). (d) Embroidery from vanity handkerchief, Denmark (1818).

51

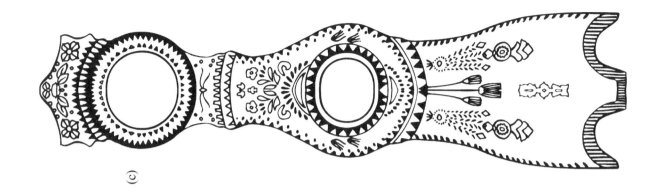

(c)

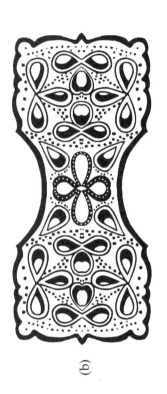

(b)

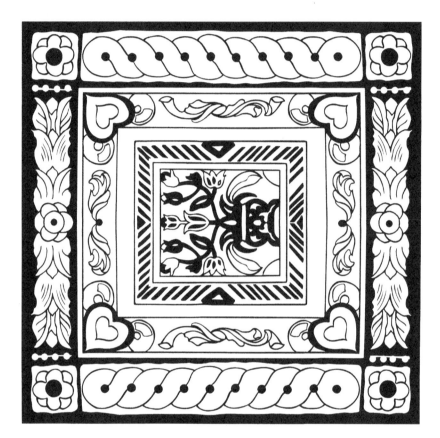

Sweden

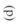

(d)

(a)

52

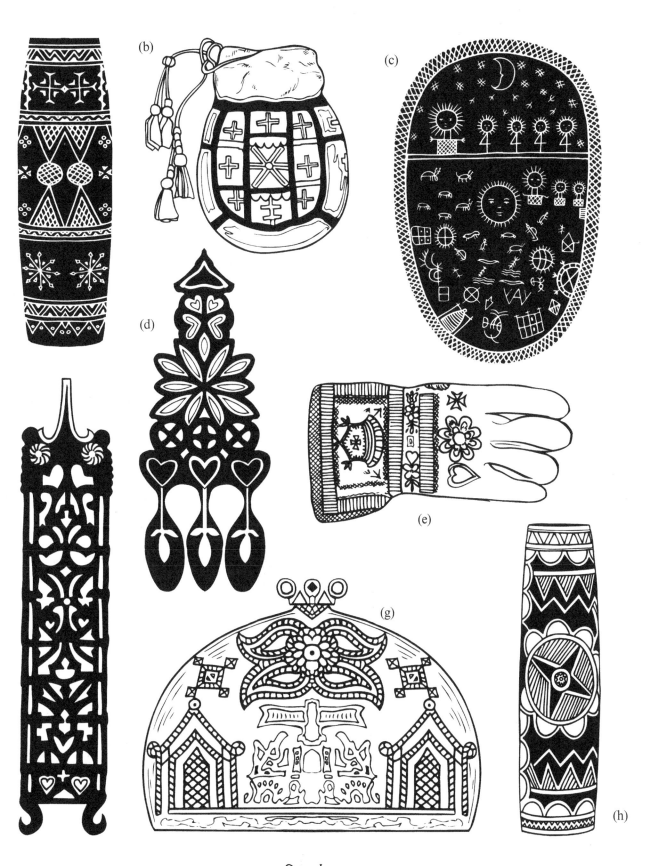

Sweden

Knife handle of bone incised with ornament, Swedish Lapland. *(b)* Leather pouch with cloth mosaic, Swedish [Lapl]and. *(c)* Front of a wooden musician's drum, Swedish Lapland. *(d)* Carved wooden spoon, Dalarne (19th century). [L]eather glove embroidered with silk and hemmed in silver tape (18th century). *(f)* Flax holder, Vasterbotten (19th [cent]ury). *(g)* Ornament carved from bone with incised design, Swedish Lapland. *(h)* Knife handle of bone incised with [orna]ment, Swedish Lapland.

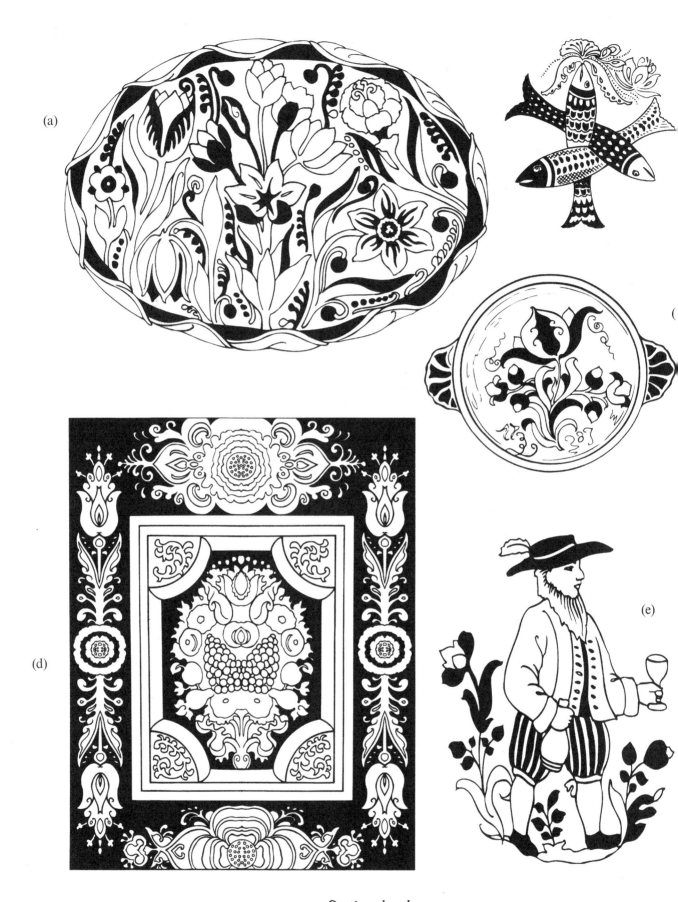

Switzerland

(a) Painted design from wooden box lid, Baden, Aargua (19th century). (b) Center design from plate, Heimburg century). (c) Painted bowl cover, Langnau (1781). (d) Painted wardrobe door, Stein, Canton Appenzell (1745). (e) design, Langnau (1778).

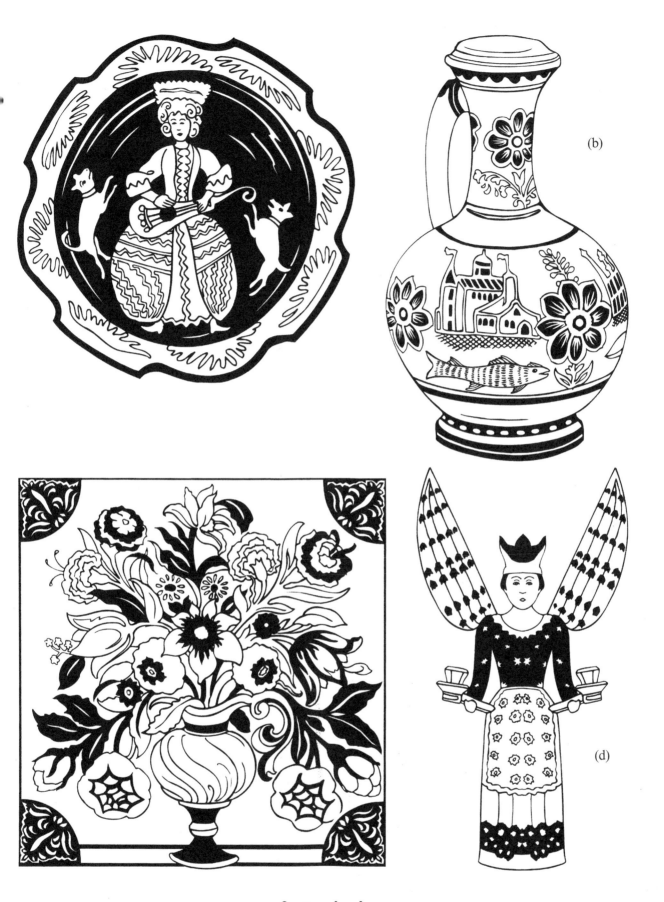

Switzerland

Plate, Heimberg (1789). *(b)* Jug with pewter lid, western Switzerland (18th century). *(c)* Cupboard door painting, n, Canton Appenzell (1766). *(d)* Wooden Christmas angel, Erzgebirge, Saxony (19th century).

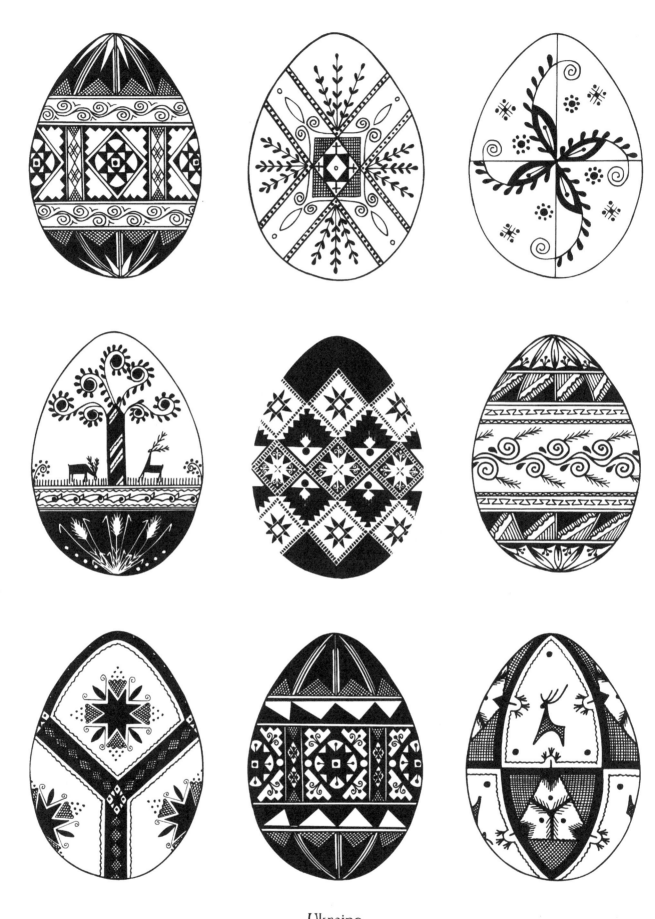

Ukraine

Ukrainian Easter eggs (Pysanky).

Ukraine

(a) Fish motif. (b) Detail of Ukrainian Easter egg. (c) Fish motif. (d) Goat and flower motif. (e) Bird motif.

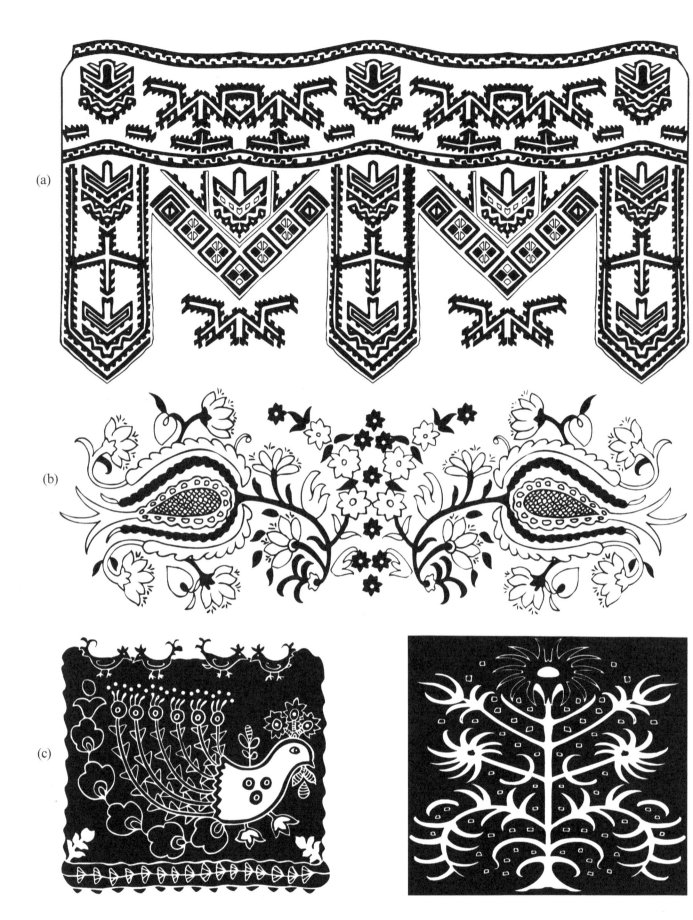

Yugoslavia

(a) Wool embroidery on woman's cotton shirt, Vodna near Skoplje, Macedonia (19th century). *(b–d)* Silk and gold embroidery on cloth made by Muslim women from Bosnia (19th century).

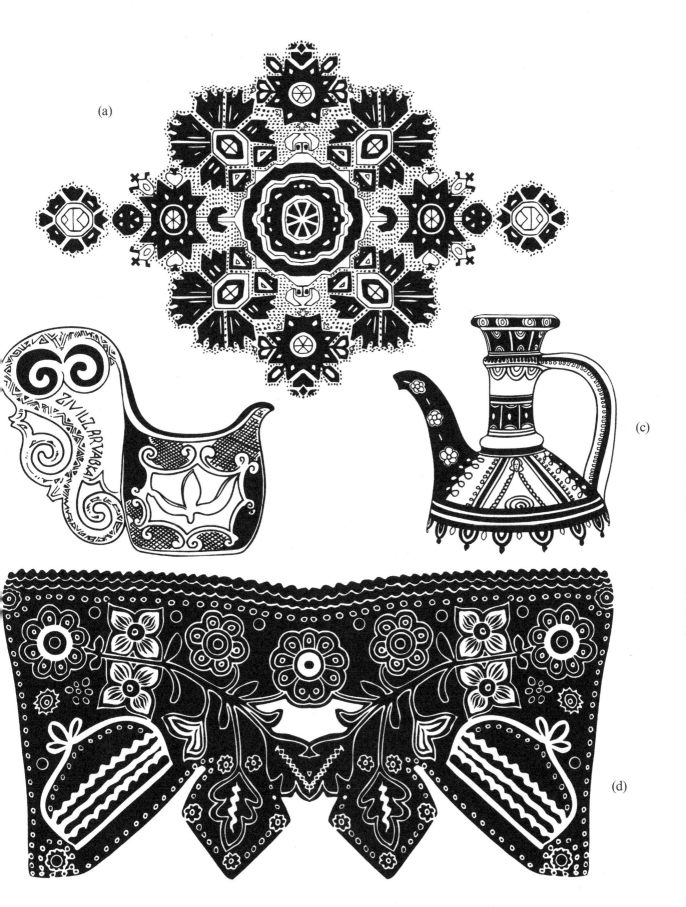

(a)

(c)

(d)

Yugoslavia

Wool embroidery on woman's cotton shirt, Vodna near Skoplje, Macedonia. *(b)* Shepherd's wood mug, Sibinji, Slovenia
(... century). *(c)* Pottery from Visnjica near Kiseljak, Bosnia (19th century). *(d)* Section of woman's jacket made of cloth
appliqué and sewn-cord ornament, Zagreb, Croatia (19th and 20th centuries).

59

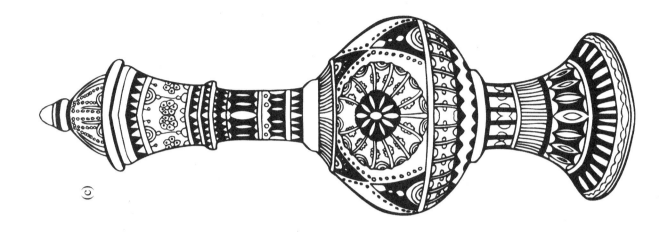

(c)

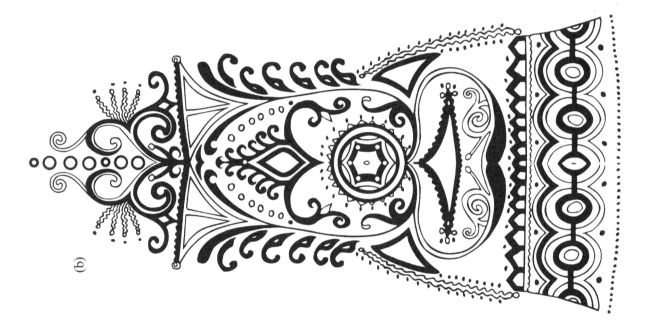

(b)

Yugoslavia

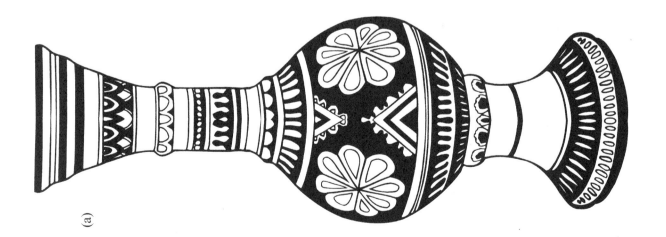

(a)

60

A CATALOG OF SELECTED DOVER
BOOKS IN ALL FIELDS OF INTEREST

100 BEST-LOVED POEMS, Edited by Philip Smith. "The Passionate Shepherd to His Love," "Shall I compare thee to a summer's day?" "Death, be not proud," "The Raven," "The Road Not Taken," plus works by Blake, Wordsworth, Byron, Shelley, Keats, many others. 96pp. 5³⁄₁₆ x 8¼. 0-486-28553-7

100 SMALL HOUSES OF THE THIRTIES, Brown-Blodgett Company. Exterior photographs and floor plans for 100 charming structures. Illustrations of models accompanied by descriptions of interiors, color schemes, closet space, and other amenities. 200 illustrations. 112pp. 8⅜ x 11. 0-486-44131-8

1000 TURN-OF-THE-CENTURY HOUSES: With Illustrations and Floor Plans, Herbert C. Chivers. Reproduced from a rare edition, this showcase of homes ranges from cottages and bungalows to sprawling mansions. Each house is meticulously illustrated and accompanied by complete floor plans. 256pp. 9⅜ x 12¼.
0-486-45596-3

101 GREAT AMERICAN POEMS, Edited by The American Poetry & Literacy Project. Rich treasury of verse from the 19th and 20th centuries includes works by Edgar Allan Poe, Robert Frost, Walt Whitman, Langston Hughes, Emily Dickinson, T. S. Eliot, other notables. 96pp. 5³⁄₁₆ x 8¼. 0-486-40158-8

101 GREAT SAMURAI PRINTS, Utagawa Kuniyoshi. Kuniyoshi was a master of the warrior woodblock print — and these 18th-century illustrations represent the pinnacle of his craft. Full-color portraits of renowned Japanese samurais pulse with movement, passion, and remarkably fine detail. 112pp. 8⅜ x 11. 0-486-46523-3

ABC OF BALLET, Janet Grosser. Clearly worded, abundantly illustrated little guide defines basic ballet-related terms: arabesque, battement, pas de chat, relevé, sissonne, many others. Pronunciation guide included. Excellent primer. 48pp. 4³⁄₁₆ x 5¾.
0-486-40871-X

ACCESSORIES OF DRESS: An Illustrated Encyclopedia, Katherine Lester and Bess Viola Oerke. Illustrations of hats, veils, wigs, cravats, shawls, shoes, gloves, and other accessories enhance an engaging commentary that reveals the humor and charm of the many-sided story of accessorized apparel. 644 figures and 59 plates. 608pp. 6⅛ x 9¼.
0-486-43378-1

ADVENTURES OF HUCKLEBERRY FINN, Mark Twain. Join Huck and Jim as their boyhood adventures along the Mississippi River lead them into a world of excitement, danger, and self-discovery. Humorous narrative, lyrical descriptions of the Mississippi valley, and memorable characters. 224pp. 5³⁄₁₆ x 8¼. 0-486-28061-6

ALICE STARMORE'S BOOK OF FAIR ISLE KNITTING, Alice Starmore. A noted designer from the region of Scotland's Fair Isle explores the history and techniques of this distinctive, stranded-color knitting style and provides copious illustrated instructions for 14 original knitwear designs. 208pp. 8⅜ x 10⅞. 0-486-47218-3

Browse over 9,000 books at www.doverpublications.com

ALICE'S ADVENTURES IN WONDERLAND, Lewis Carroll. Beloved classic about a little girl lost in a topsy-turvy land and her encounters with the White Rabbit, March Hare, Mad Hatter, Cheshire Cat, and other delightfully improbable characters. 42 illustrations by Sir John Tenniel. 96pp. 5³⁄₁₆ x 8¼. 0-486-27543-4

AMERICA'S LIGHTHOUSES: An Illustrated History, Francis Ross Holland. Profusely illustrated fact-filled survey of American lighthouses since 1716. Over 200 stations — East, Gulf, and West coasts, Great Lakes, Hawaii, Alaska, Puerto Rico, the Virgin Islands, and the Mississippi and St. Lawrence Rivers. 240pp. 8 x 10¾.
0-486-25576-X

AN ENCYCLOPEDIA OF THE VIOLIN, Alberto Bachmann. Translated by Frederick H. Martens. Introduction by Eugene Ysaye. First published in 1925, this renowned reference remains unsurpassed as a source of essential information, from construction and evolution to repertoire and technique. Includes a glossary and 73 illustrations. 496pp. 6⅛ x 9¼. 0-486-46618-3

ANIMALS: 1,419 Copyright-Free Illustrations of Mammals, Birds, Fish, Insects, etc., Selected by Jim Harter. Selected for its visual impact and ease of use, this outstanding collection of wood engravings presents over 1,000 species of animals in extremely lifelike poses. Includes mammals, birds, reptiles, amphibians, fish, insects, and other invertebrates. 284pp. 9 x 12. 0-486-23766-4

THE ANNALS, Tacitus. Translated by Alfred John Church and William Jackson Brodribb. This vital chronicle of Imperial Rome, written by the era's great historian, spans A.D. 14-68 and paints incisive psychological portraits of major figures, from Tiberius to Nero. 416pp. 5³⁄₁₆ x 8¼. 0-486-45236-0

ANTIGONE, Sophocles. Filled with passionate speeches and sensitive probing of moral and philosophical issues, this powerful and often-performed Greek drama reveals the grim fate that befalls the children of Oedipus. Footnotes. 64pp. 5³⁄₁₆ x 8 ¼. 0-486-27804-2

ART DECO DECORATIVE PATTERNS IN FULL COLOR, Christian Stoll. Reprinted from a rare 1910 portfolio, 160 sensuous and exotic images depict a breathtaking array of florals, geometrics, and abstracts — all elegant in their stark simplicity. 64pp. 8⅜ x 11. 0-486-44862-2

THE ARTHUR RACKHAM TREASURY: 86 Full-Color Illustrations, Arthur Rackham. Selected and Edited by Jeff A. Menges. A stunning treasury of 86 full-page plates span the famed English artist's career, from *Rip Van Winkle* (1905) to masterworks such as *Undine, A Midsummer Night's Dream,* and *Wind in the Willows* (1939). 96pp. 8⅜ x 11.
0-486-44685-9

THE AUTHENTIC GILBERT & SULLIVAN SONGBOOK, W. S. Gilbert and A. S. Sullivan. The most comprehensive collection available, this songbook includes selections from every one of Gilbert and Sullivan's light operas. Ninety-two numbers are presented uncut and unedited, and in their original keys. 410pp. 9 x 12.
0-486-23482-7

THE AWAKENING, Kate Chopin. First published in 1899, this controversial novel of a New Orleans wife's search for love outside a stifling marriage shocked readers. Today, it remains a first-rate narrative with superb characterization. New introductory Note. 128pp. 5³⁄₁₆ x 8¼. 0-486-27786-0

BASIC DRAWING, Louis Priscilla. Beginning with perspective, this commonsense manual progresses to the figure in movement, light and shade, anatomy, drapery, composition, trees and landscape, and outdoor sketching. Black-and-white illustrations throughout. 128pp. 8⅜ x 11. 0-486-45815-6

Browse over 9,000 books at www.doverpublications.com